COLOR ME
FEARLESS

———

First published in the United States of America in 2016 by
Race Point Publishing, a member of
Quarto Publishing Group USA Inc.
142 West 36th Street, 4th Floor
New York, New York 10018
www.quartoknows.com

10 9 8 7 6 5 4

ISBN 978-1-63106-195-0

Editorial Director: Jeannine Dillon
Managing Editor: Erin Canning
Cover Design: Jacqui Caulton
Interior Design: Rosamund Saunders

Cover artwork by Angela Porter

Printed in China

This book provides general information on various widely known and widely
accepted images that tend to evoke feelings of strength and confidence.
However, it should not be relied upon as recommending or promoting any
specific diagnosis or method of treatment for a particular condition, and it
is not intended as a substitute for medical advice or for direct diagnosis and
treatment of a medical condition by a qualified physician. Readers who have
questions about a particular condition, possible treatments for that condition,
or possible reactions from the condition or its treatment should consult a
physician or other qualified healthcare professional.

COLOR ME FEARLESS

Nearly 100 Coloring Templates to Boost Strength and Courage

Lacy Mucklow, MA, ATR-BC, LPAT, LCPAT

Illustrated by Angela Porter

Race Point
PUBLISHING

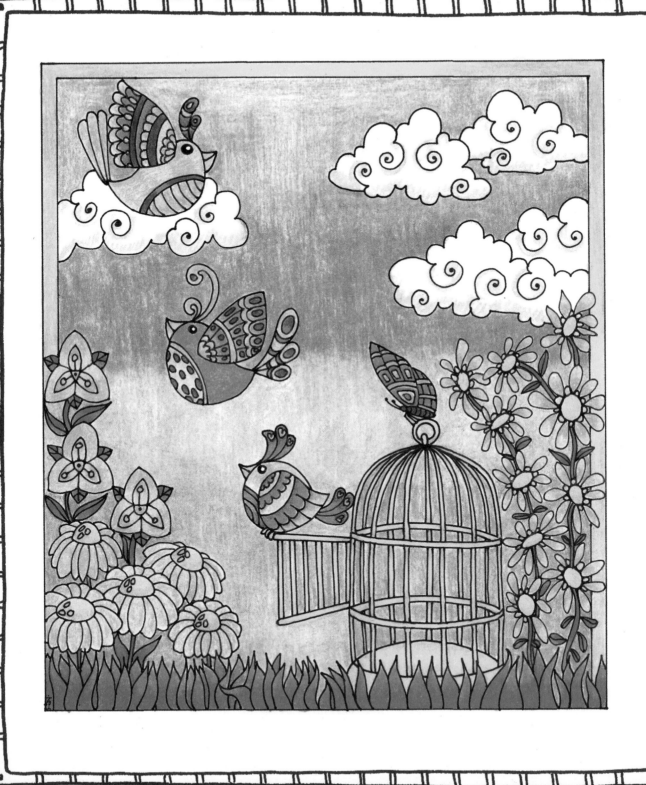

CONTENTS

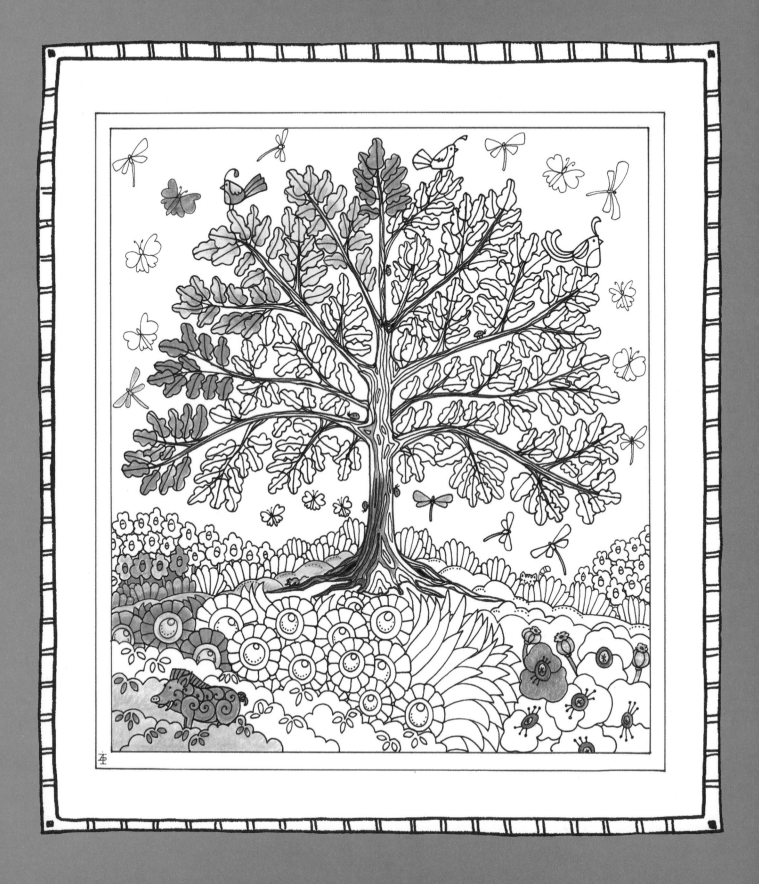

INTRODUCTION

Why make a coloring book for adults? As children, many of us enjoyed coloring our favorite characters or scenes in books with our trusty pack of crayons. But as we got older, added responsibilities came along, which pushed aside things we used to do for sheer enjoyment.

One of the great things about coloring is that it is highly successful for everyone, even if you lack artistic instruction or experience, and it can be as nuanced or generalized as the colorer wishes. Having guidelines eases performance anxiety, and being able to add your own colors helps make the experience more personal. The act of coloring can also be meditative in and of itself, bringing about mindfulness just through the simple act of picking up a colored pencil or crayon and focusing your creativity and thoughts on a single coloring exercise.

Despite what you may have learned about art and color in your lifetime, there is no right or wrong way to use this book; you have the freedom to color it however you wish in whatever way works best for you. Conceptually, in "Color Me Fearless," the chapters are divided into seven characteristics that are critical in the development

of fearlessness—courage, strength, resilience, confidence, power, adventure, and freedom—and that can continue to be cultivated as you become more intrepid. The images included to color evoke these fear-busting characteristics with archetypal symbols from across time and cultures, as well as with more abstract and symbolic renderings that hold meanings of stability, growth, transcendence, and empowerment to further propel your psyche into a confident way of being. Themes of exercising "go-get-'em" attitudes, being unfettered, showing fortitude, trying new things, persevering, thriving, overcoming, and taking healthy risks are sprinkled throughout these chapters. Visual inspiration and the act of coloring combined with the carefully chosen subject matter can assist in influencing the way we think and feel. This book seeks to bring you into a positive space to help foster being fearless, one small step at a time.

We realize that what inspires fearlessness in people can run the gamut even within "universal" categories, so we have included a variety of images within each chapter so that at least some of the pieces connect with you personally. The designs are intended for adult sensibility and dexterity rather than for children, and include actual scenes (or variations thereof) to encourage attaining fearlessness—many are more abstract in nature so that you may enjoy the intricacy of the patterns themselves, as many of us do. Most importantly, this book is about helping you suspend your mental energies for a short while and hone in on something else that aims at promoting well-being.

At the end of each chapter, a blank panel has been included so that you can have a chance to think about and draw (and color) an image that is uniquely emboldening to you—this will make the coloring experience even more personal and will hopefully keep you mindful about things and experiences that you find freeing. You may find that engaging with this book in a regular routine may be particularly helpful for you, such as beginning your morning with a coloring template to help give you a bolder outlook for the day ahead or coloring in the evening to reflect on your actions from the day. This book is intended to bring about a more confident emotional state; however, it is not meant to replace the services of a professional counselor if more direct intervention and personal guidance is needed. We hope that you enjoy this book and that it helps you find a way to color yourself fearless!

COLOR TIP

Cool colors (such as blues, greens, and purples) are considered to have calming qualities, while the warmer colors (such as red, oranges, and yellows) have more activating qualities. In addition, bright colors also tend to have more energy while pastel or tinted colors tend to communicate softer energy and darker colors or shades usually indicate lower energy. The most important thing when coloring is to figure out which colors **you** find invigorating, and then try to incorporate them into your artwork.

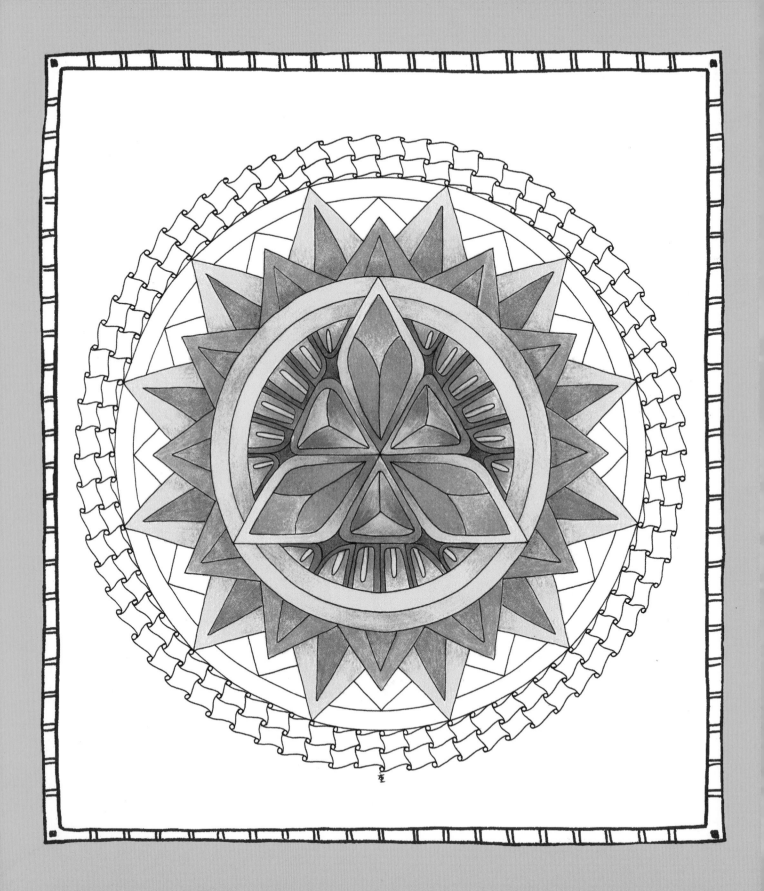

Chapter 1

COURAGE

One of the first things that typically comes to mind when thinking about fear is being able to counter it with courage. Being fearless is not always a natural state of being, nor does having courage mean that there is an absence of fear; rather, it means being brave enough to act on and move forward despite any trepidation that may be involved with a particular circumstance. Possessing and using courage allows you to push through or past the fear in order to do what needs to be done, whether it is in a crisis situation that requires an immediate response, such as in dealing with a medical emergency, or with something that you have always wanted to do but that carries a risk to accomplish it, such as skydiving. The following images are symbolic and archetypal and represent numerous cultures and eras, including icons of bravery in battle, symmetrical designs, powerful animals, and substantial geometric shapes. A blank panel is included at the end of the chapter to encourage you to draw and color an image that is significant to you in embodying courage and helping you conquer your fears.

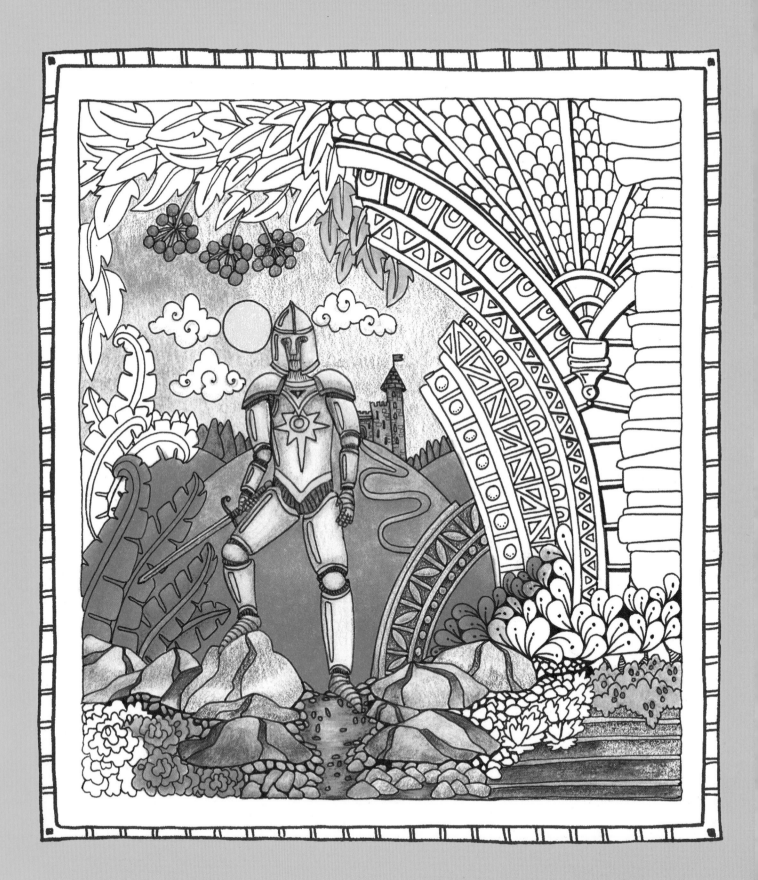

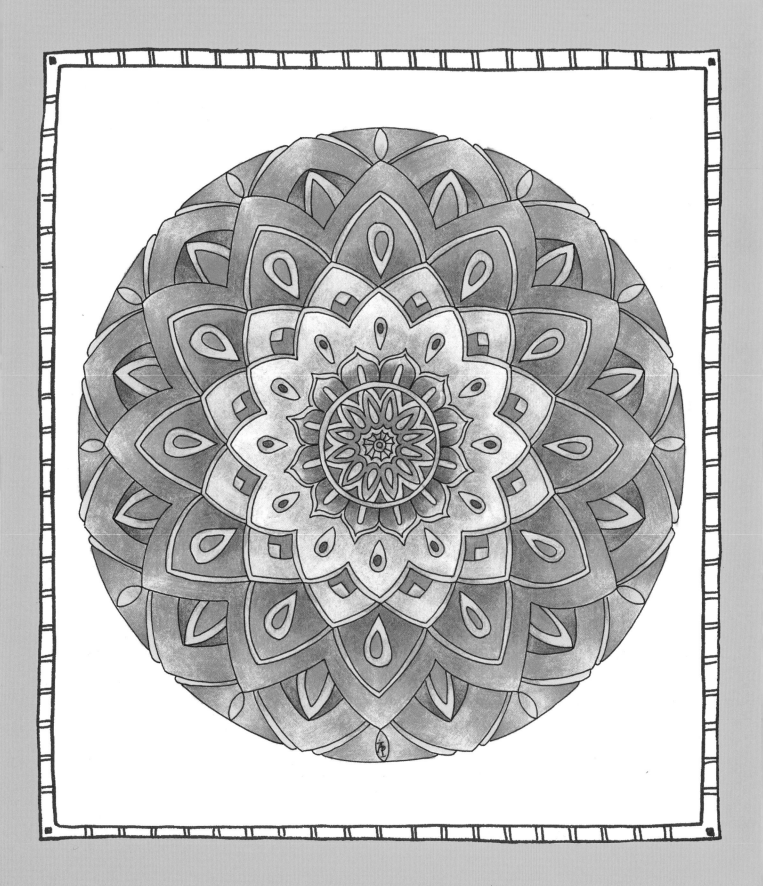

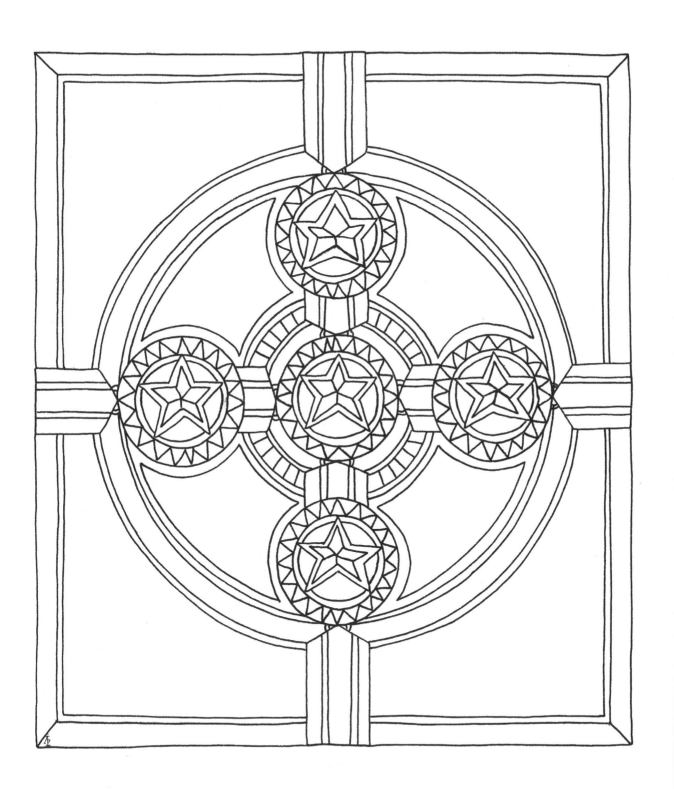

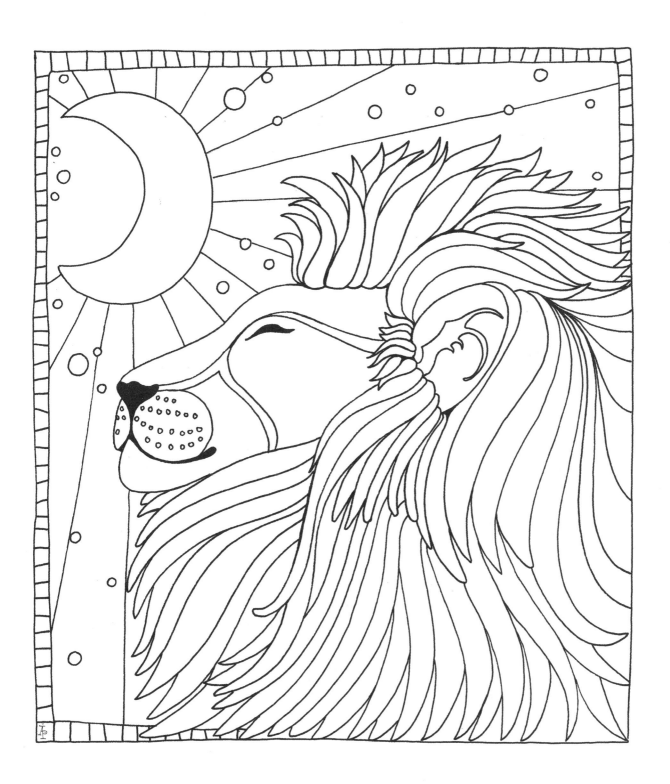

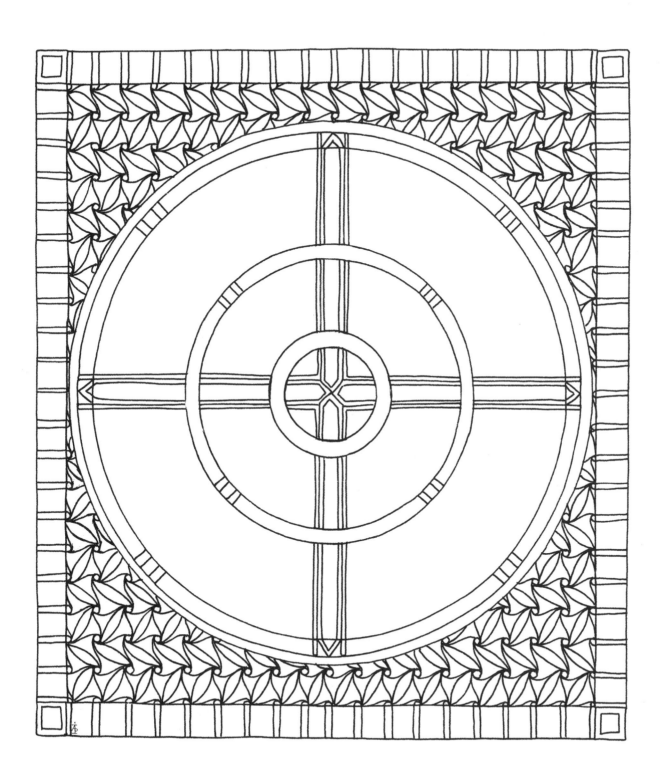

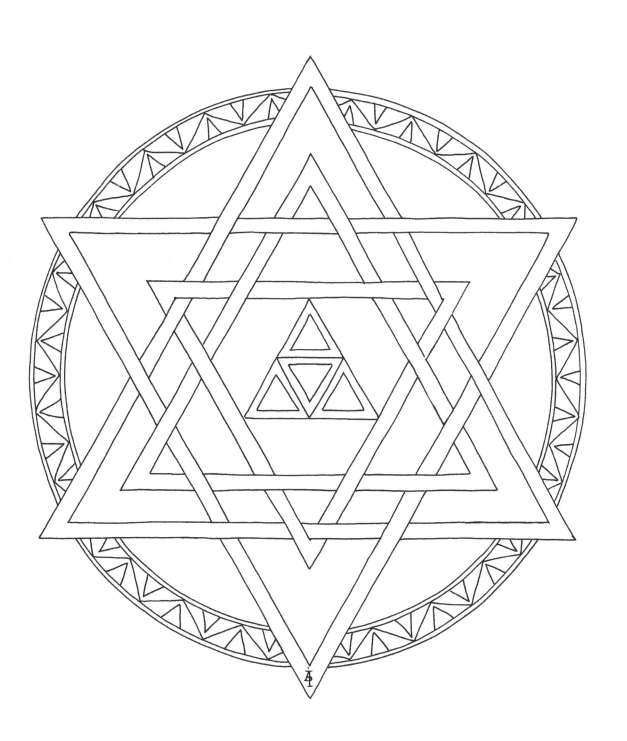

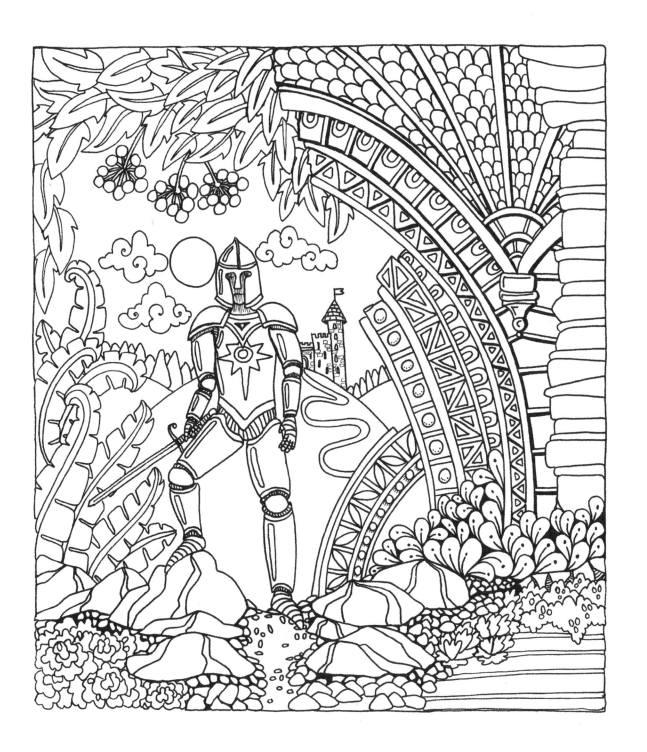

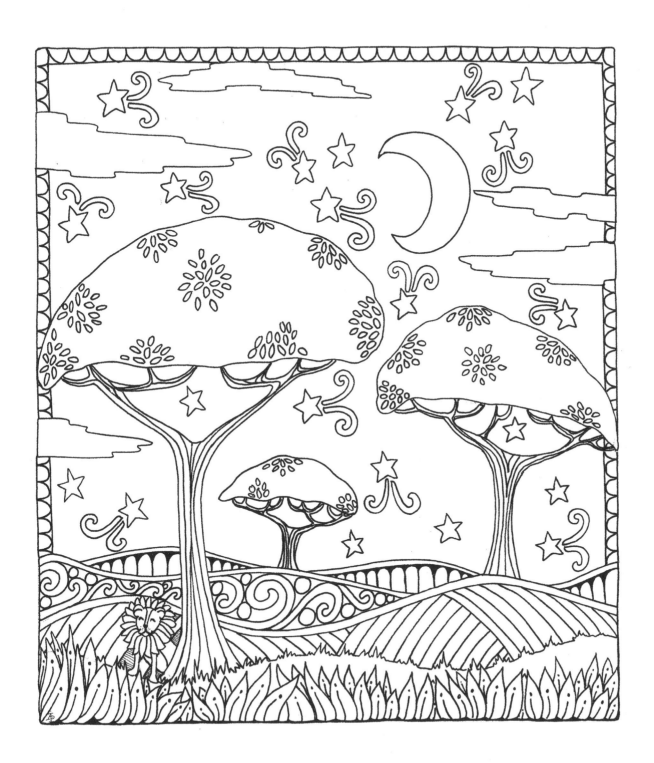

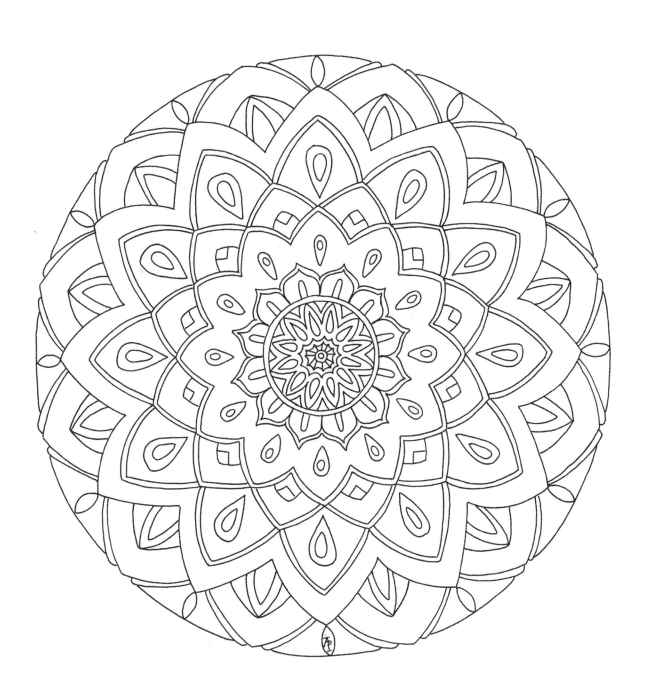

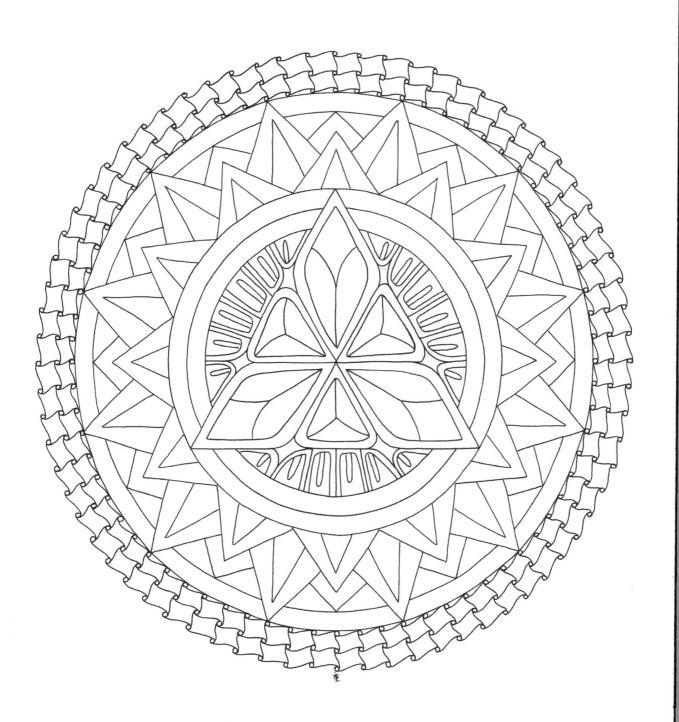

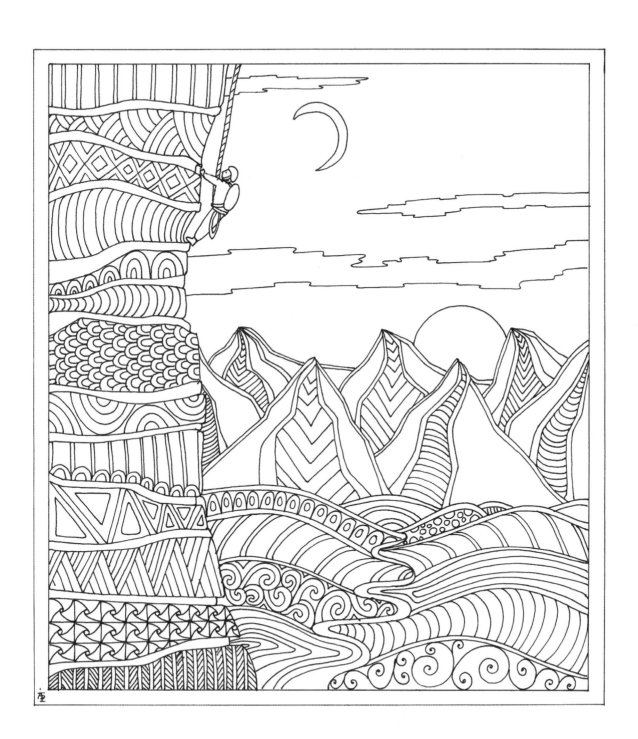

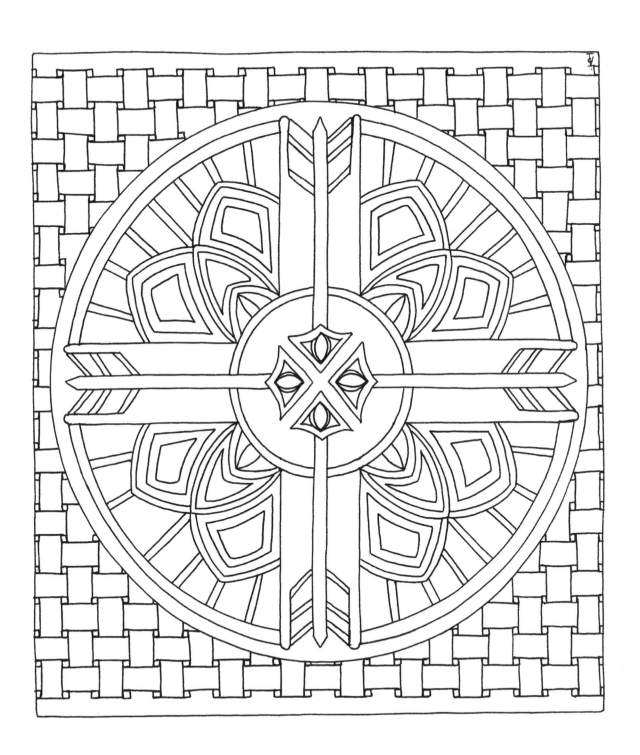

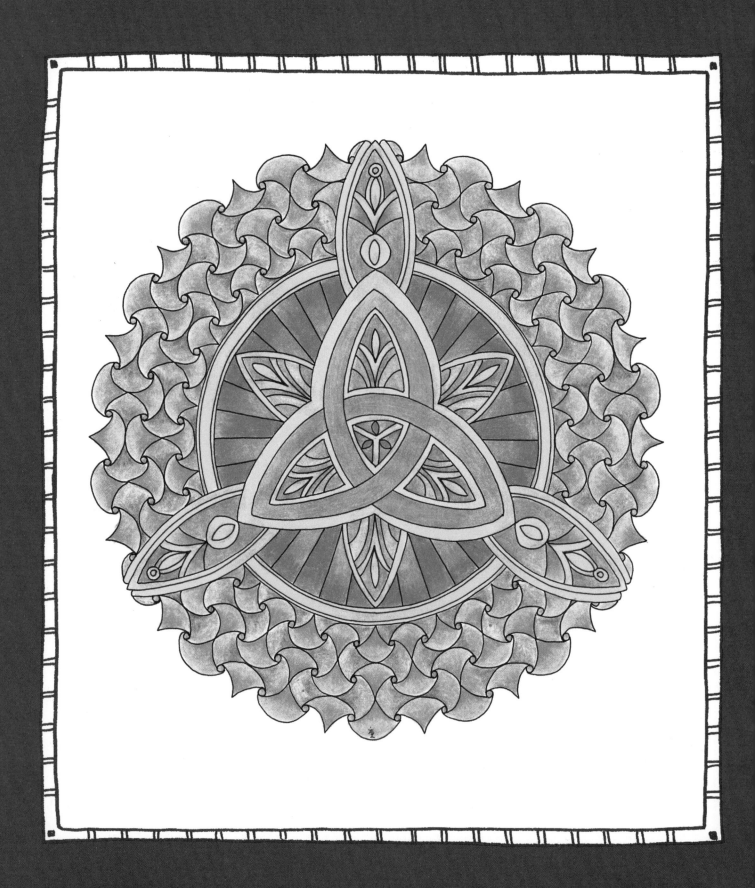

Chapter 2

STRENGTH

In order to be fearless, you first must have the strength to face the challenge. Possessing inner strength can be innate, but often this kind of strength is gained over time through experiences. Just as physical strength can only be increased or maintained through training and exercise on a regular basis, developing and maintaining inner strength (emotional, mental, psychological, and spiritual) also comes with personal discipline and preparedness, along with the navigation of life's lessons. As you gain strength from these experiences, whether through careful planning or trial by fire, they can help you to become more fearless and feel more confident to handle whatever may cross your life's path. Having this fortitude can help you persevere through a difficulty that may seem against the odds or to try something new even if the prospect seems daunting. The following images signify strength in literal and symbolic ways, including representations of strong bonds, permanence, and stability. A blank panel is included at the end of the chapter to encourage you to draw and color an image that gives you the inner strength to carry on.

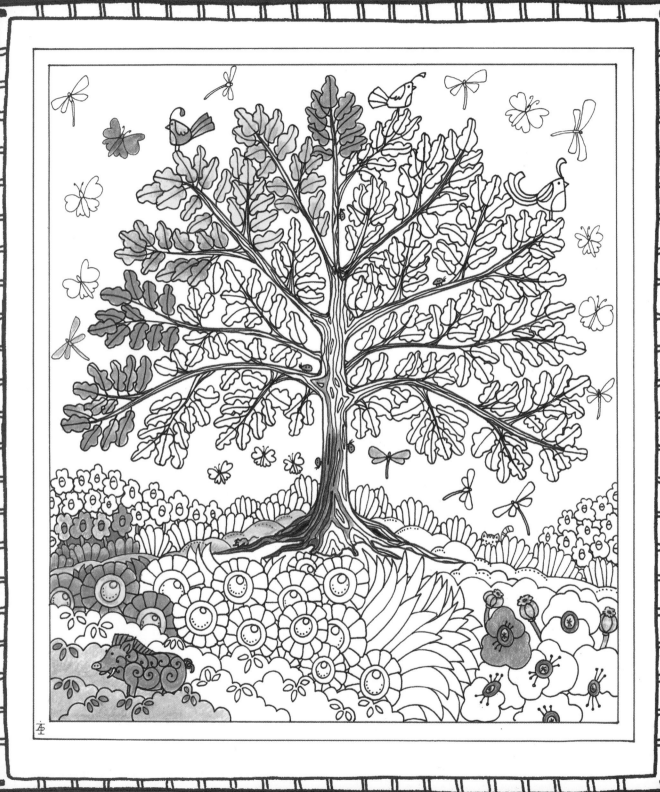

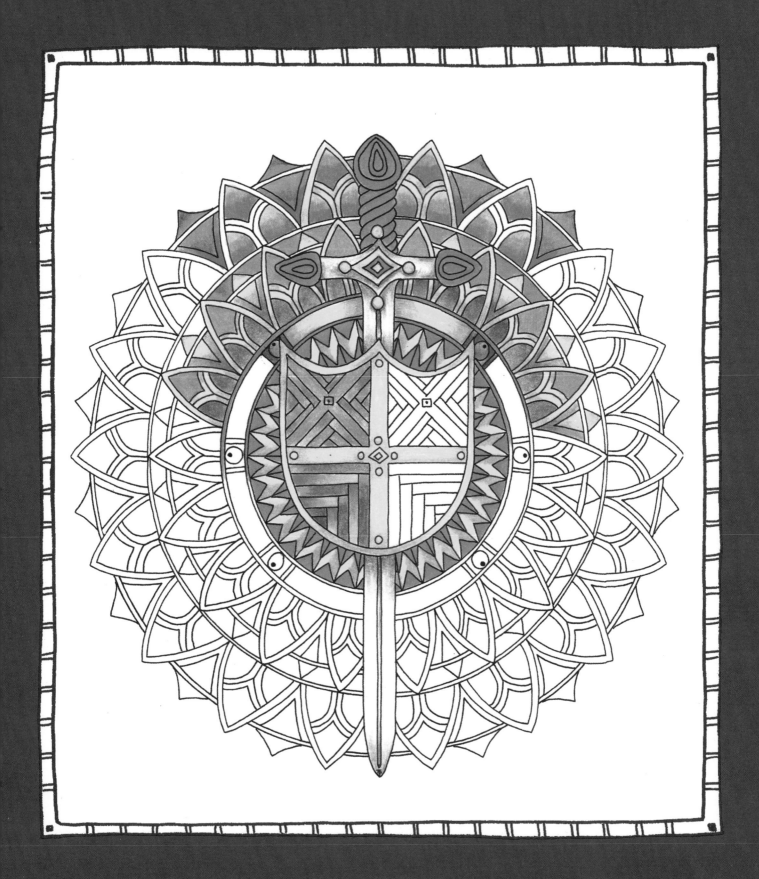

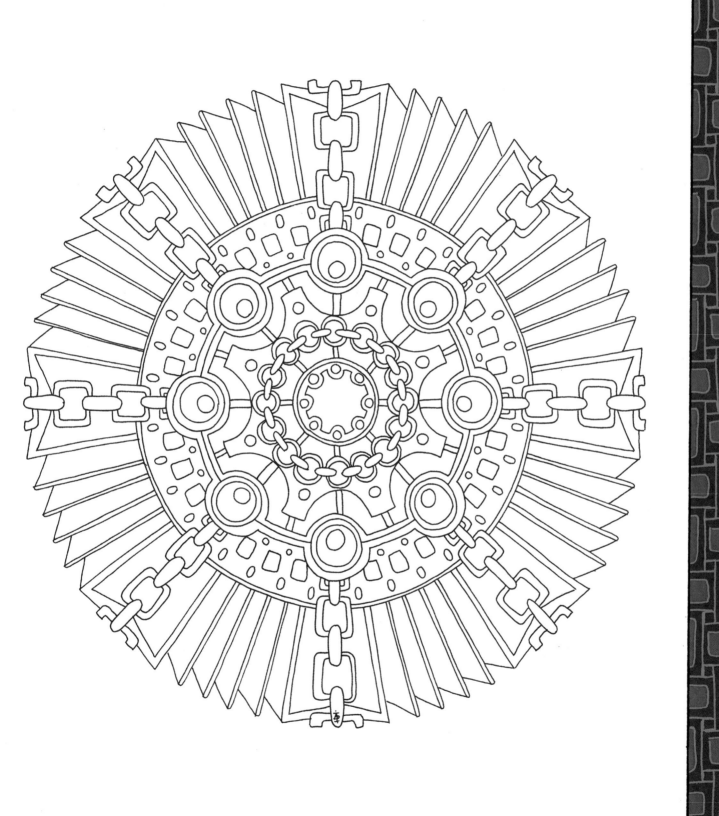

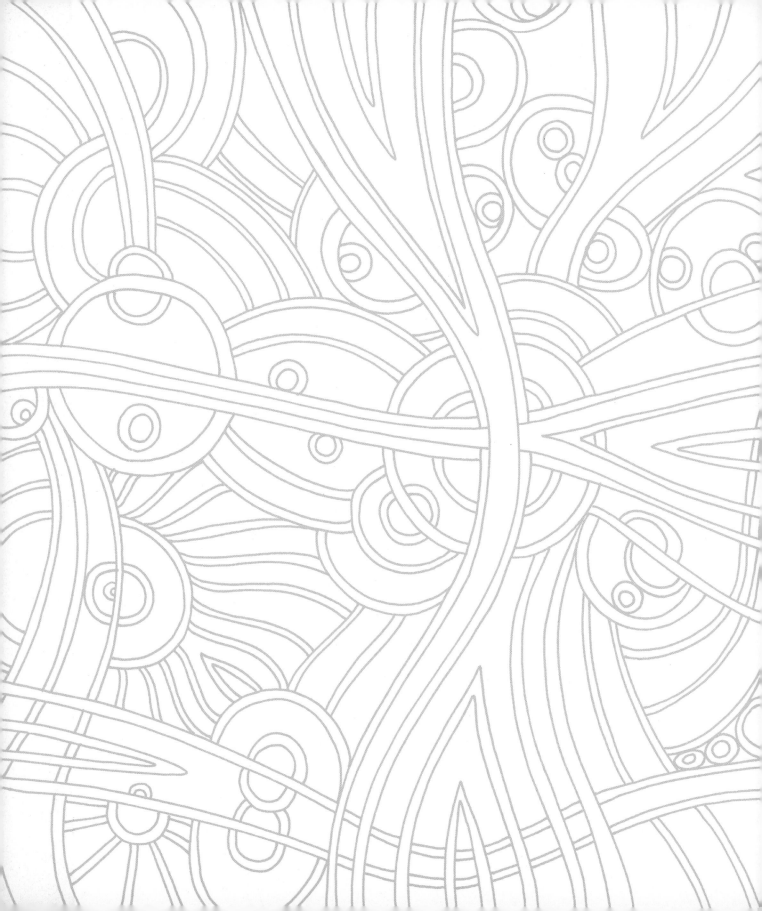

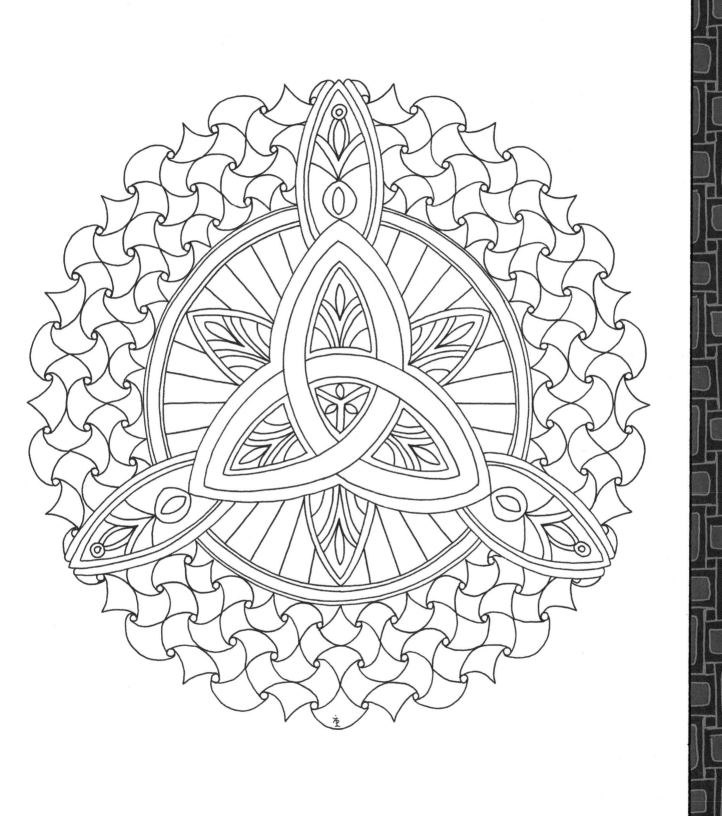

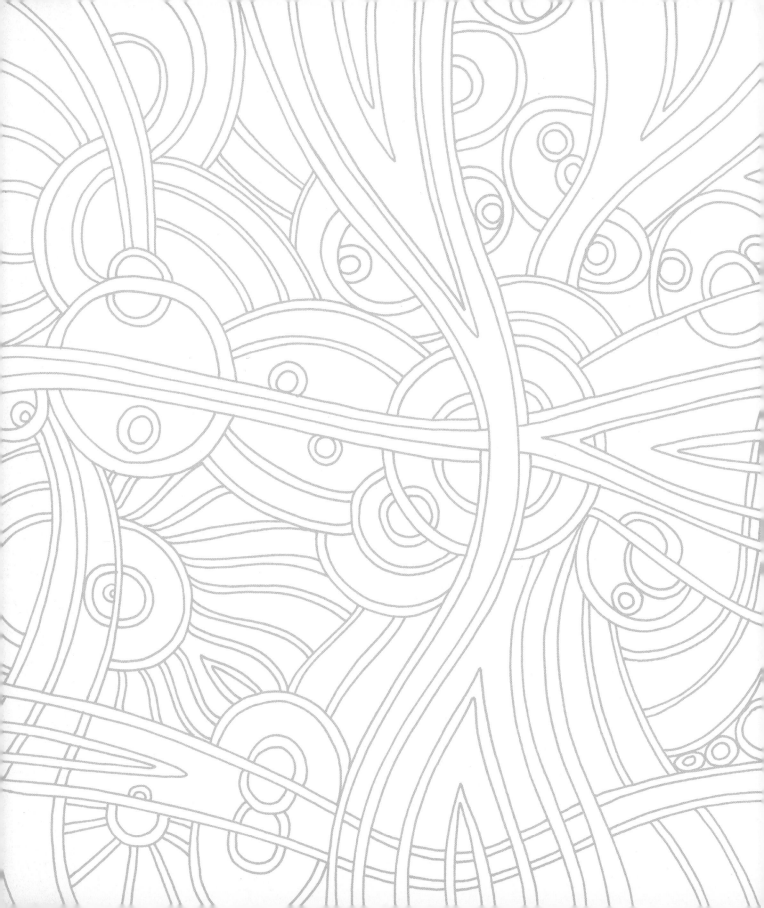

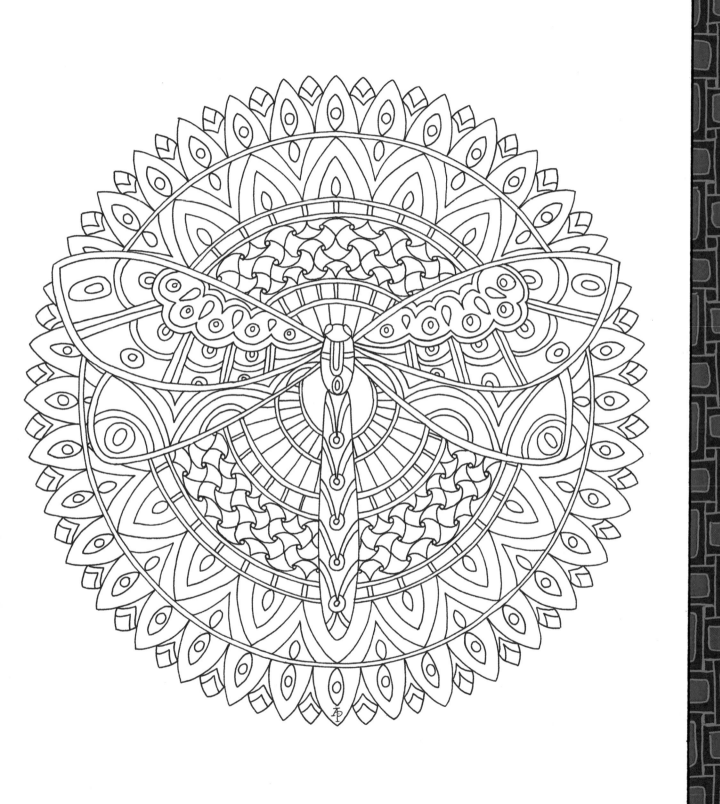

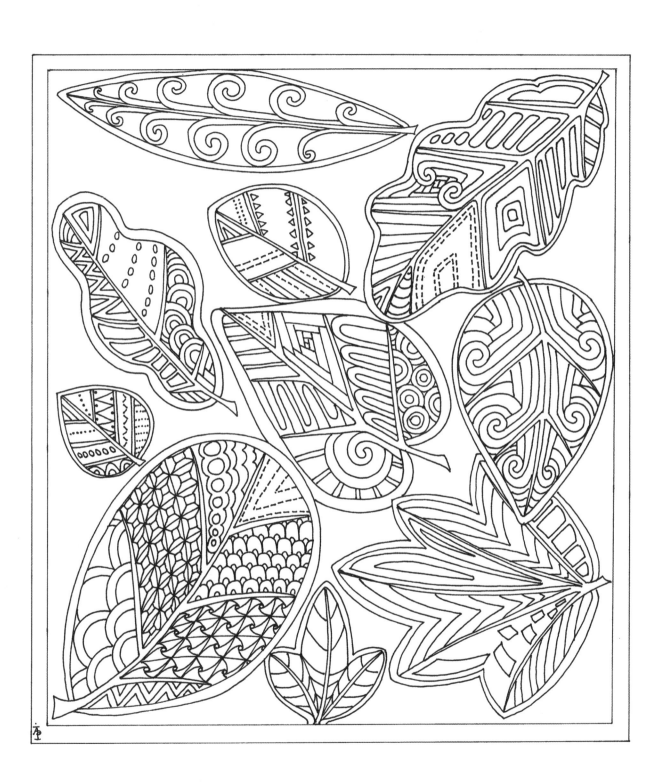

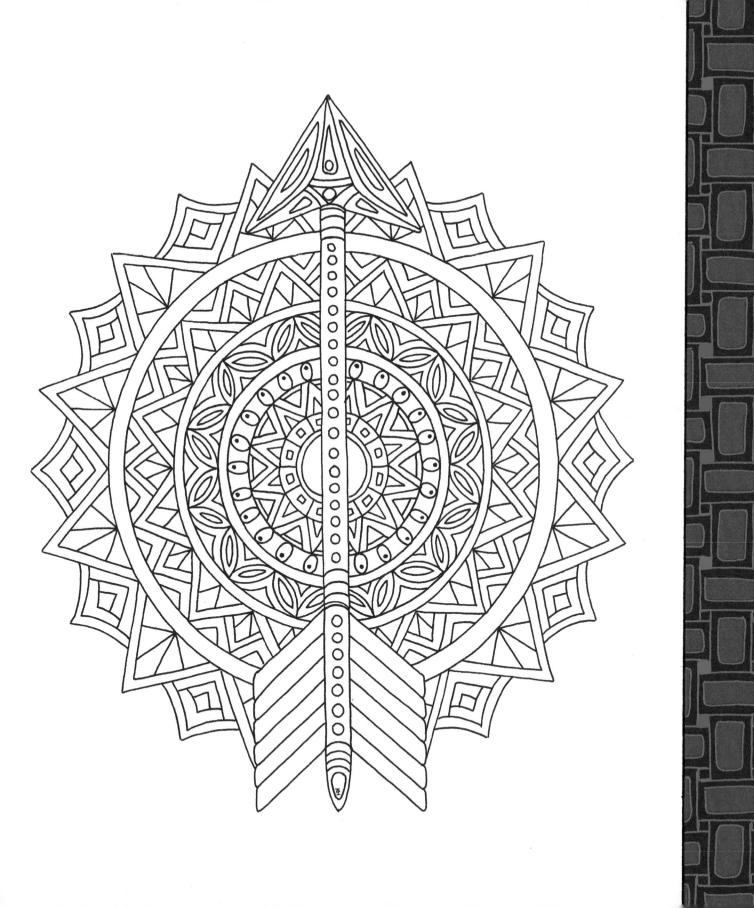

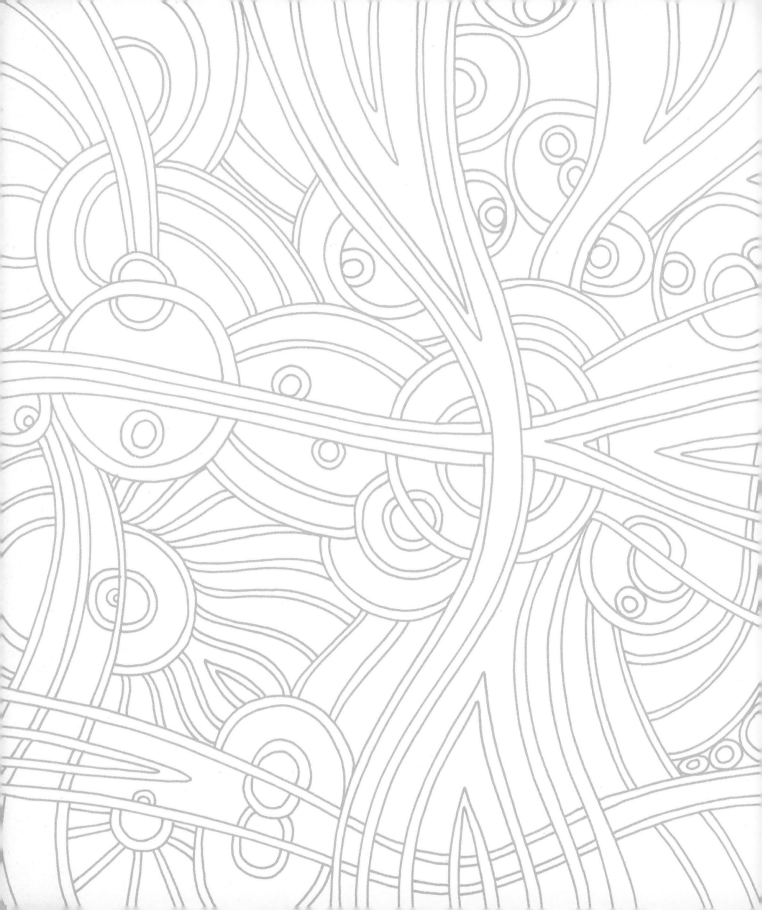

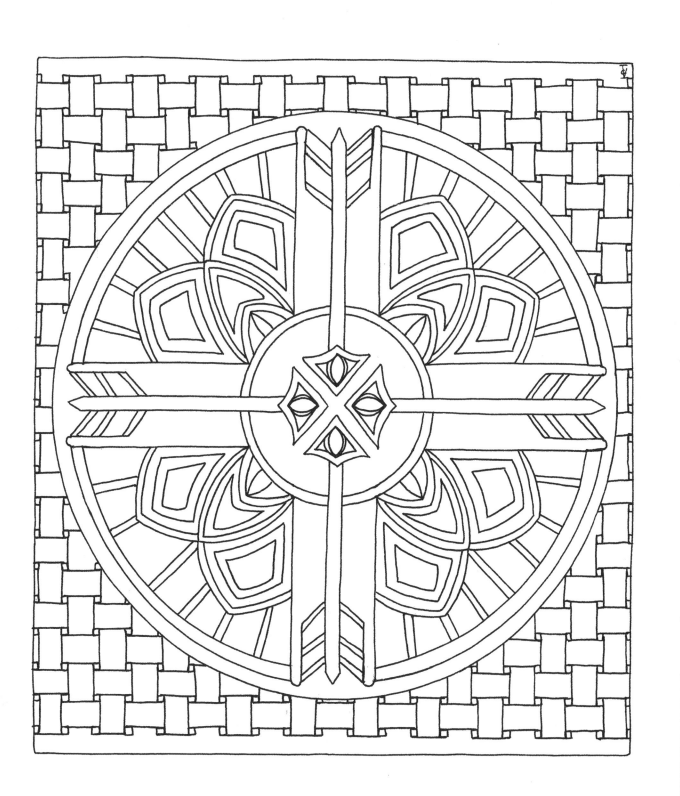

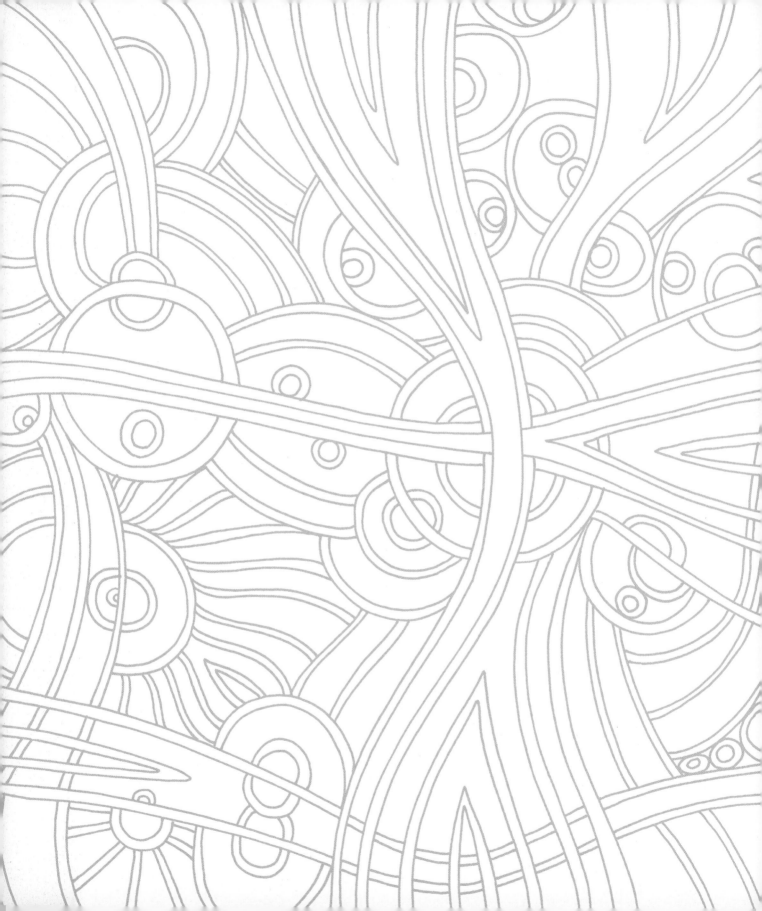

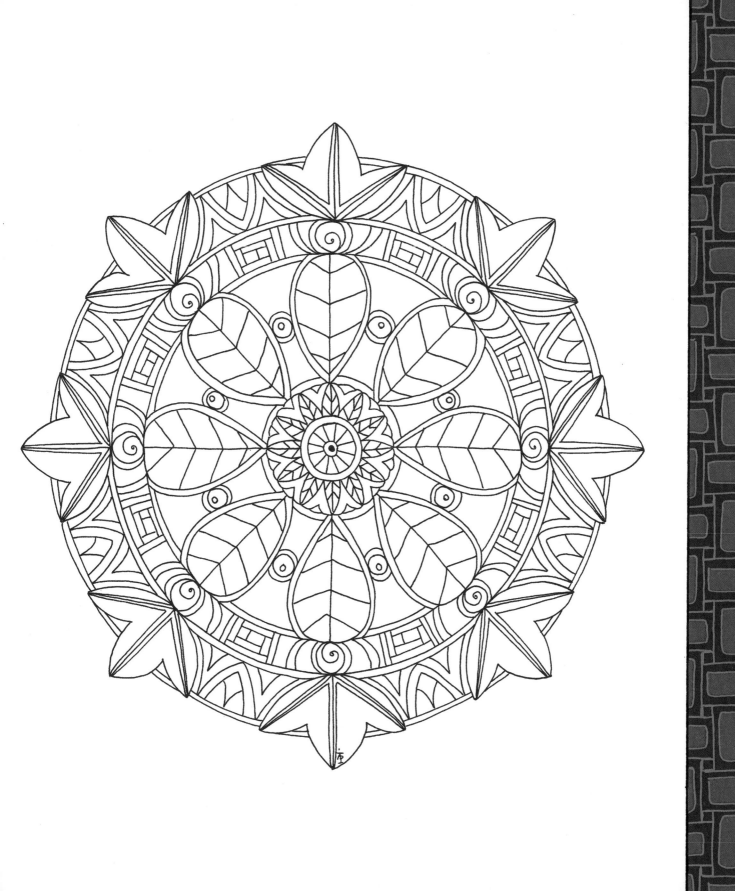

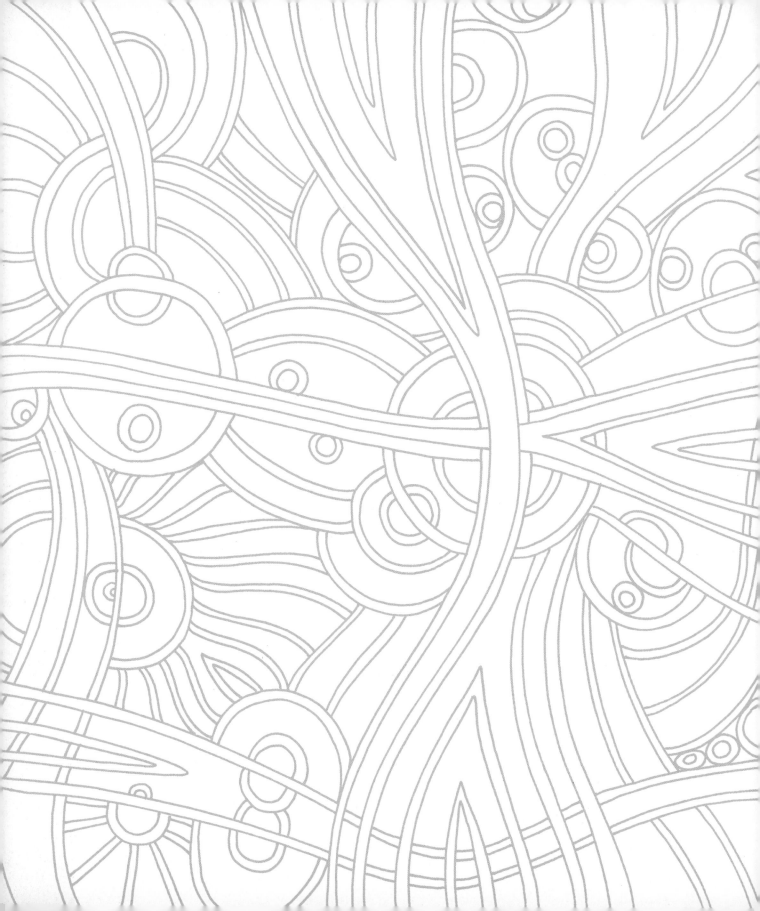

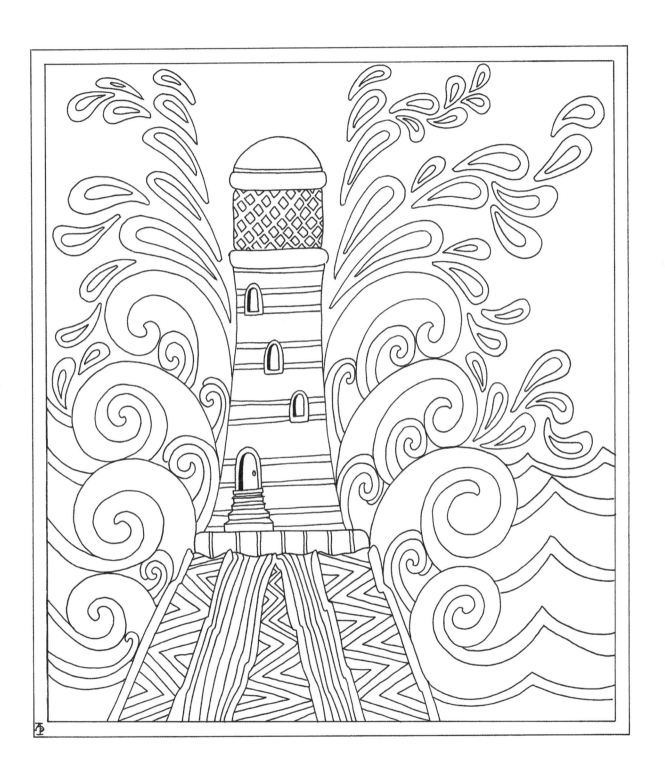

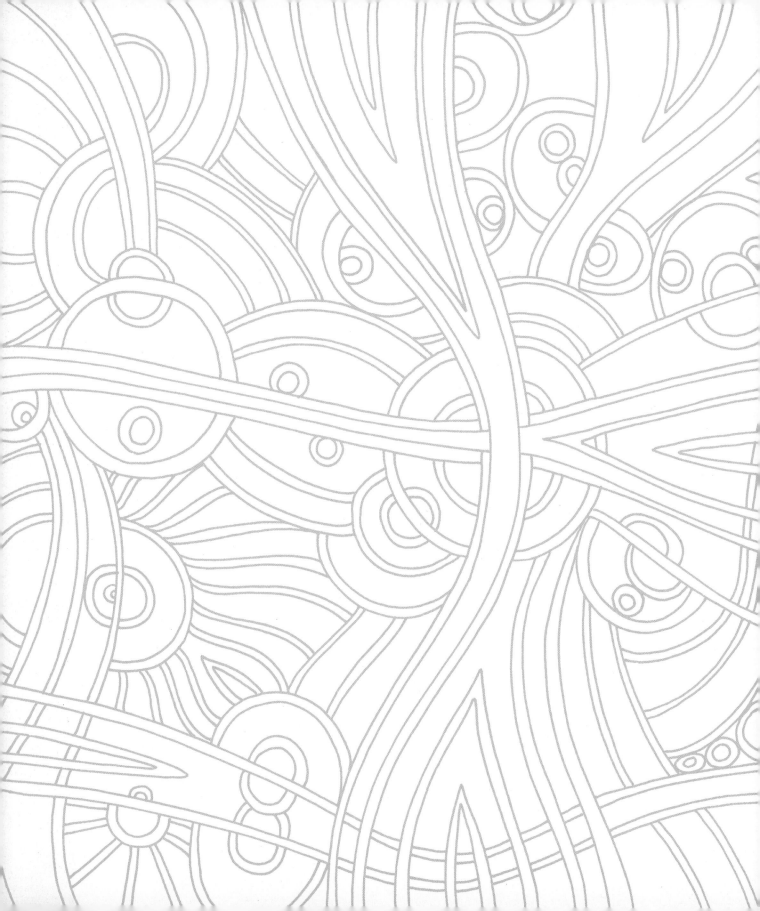

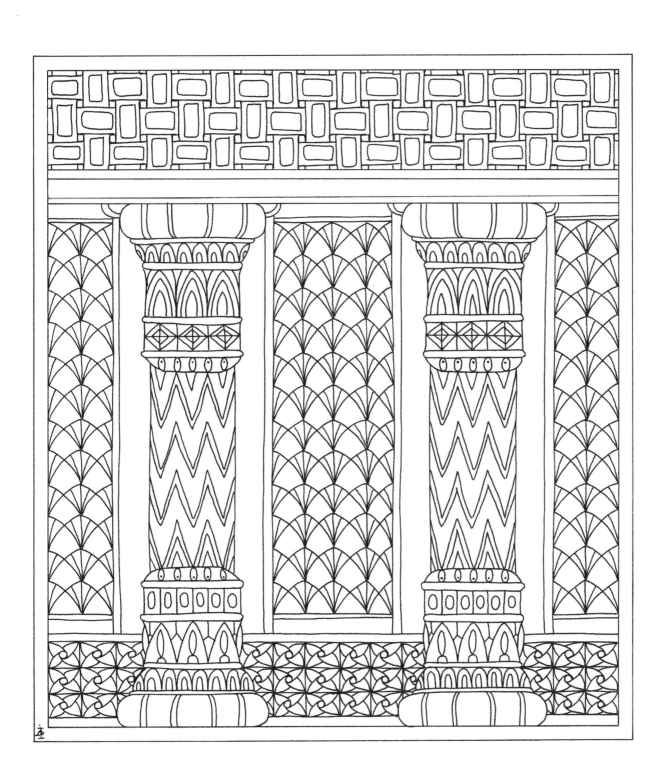

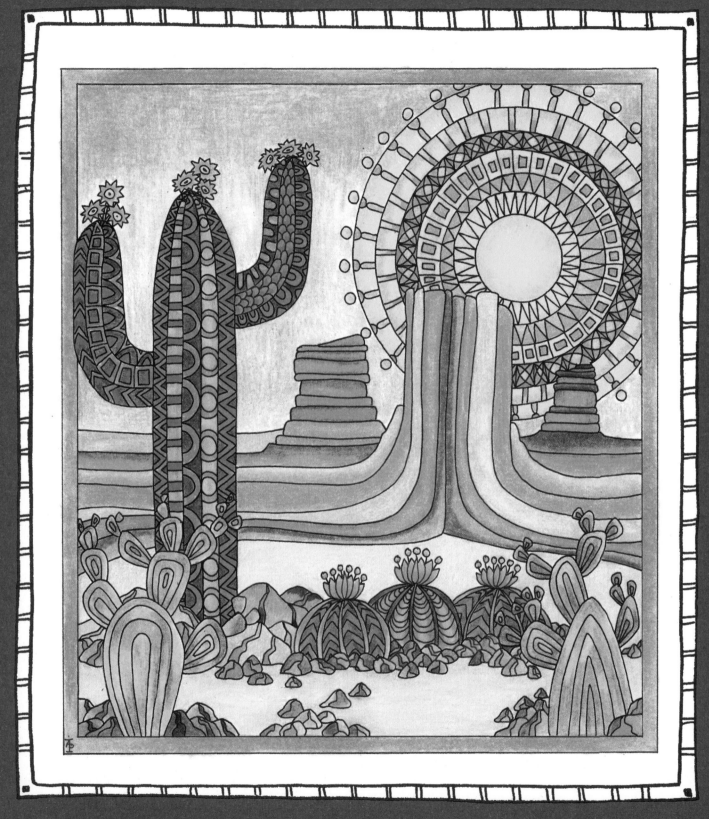

Chapter 3

RESILIENCE

Having resilience—the ability to bounce back from something difficult or traumatic—is an important factor in being fearless. We can be emotionally, psychologically, physically, spiritually, and mentally resilient. Exercising resilience is a key aspect in not only pushing through and moving beyond adversity, but also in being able to survive it, and even continue to thrive. The key is knowing what your resilience level is and finding ways to increase it as you encounter more life experiences and learn to manage them in more positive ways. Fostering this positivity can also bolster resilient responses to future challenging situations, which will help you be more fearless. The following images exemplify the rebounding and perseverant characteristics of resilience, including depictions of rebirth, endurance, survival, and flexibility. A blank panel is included at the end of the chapter to encourage you to draw and color an image that represents being resilient to you.

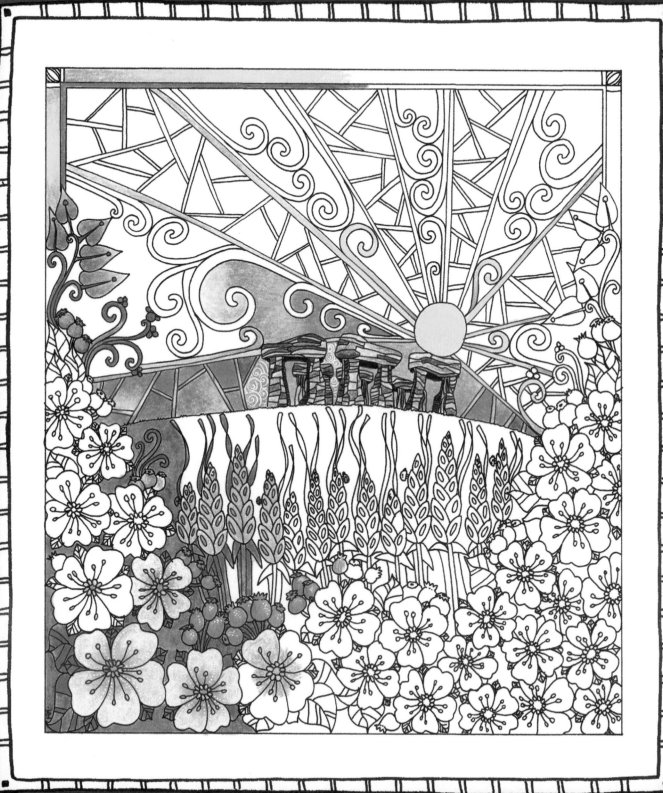

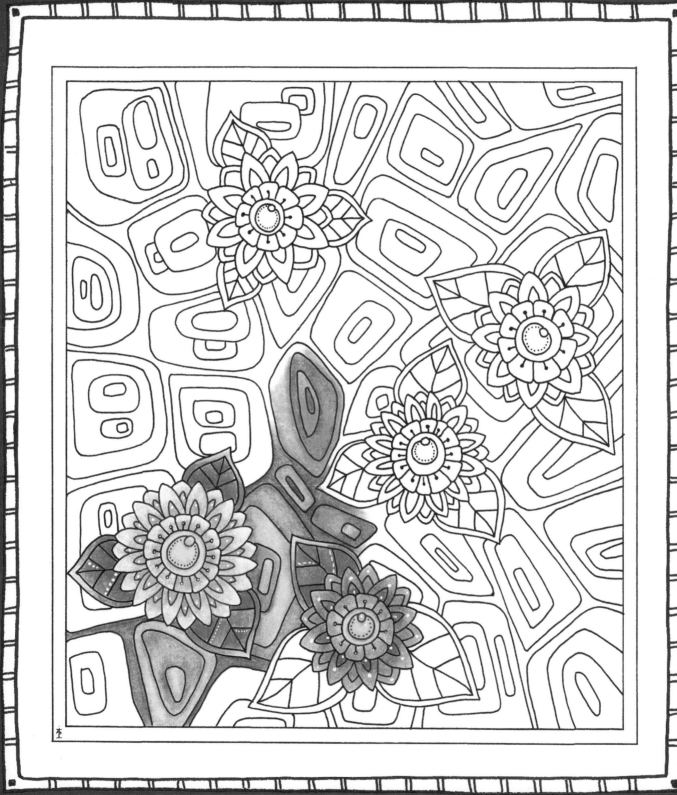

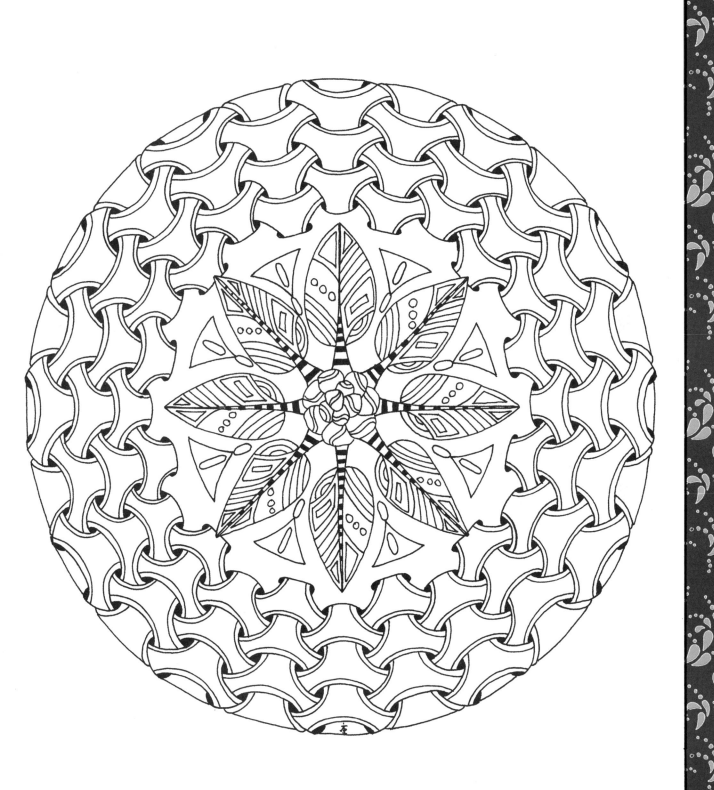

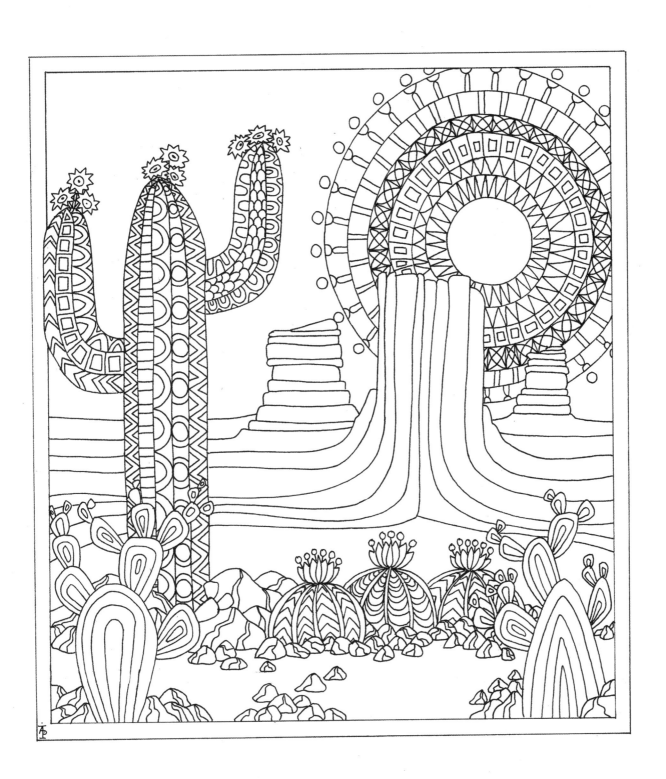

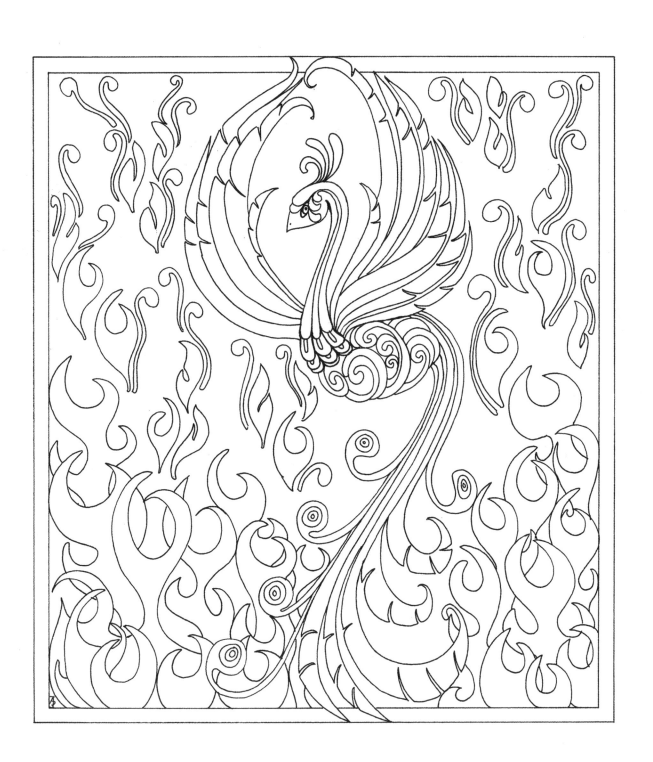

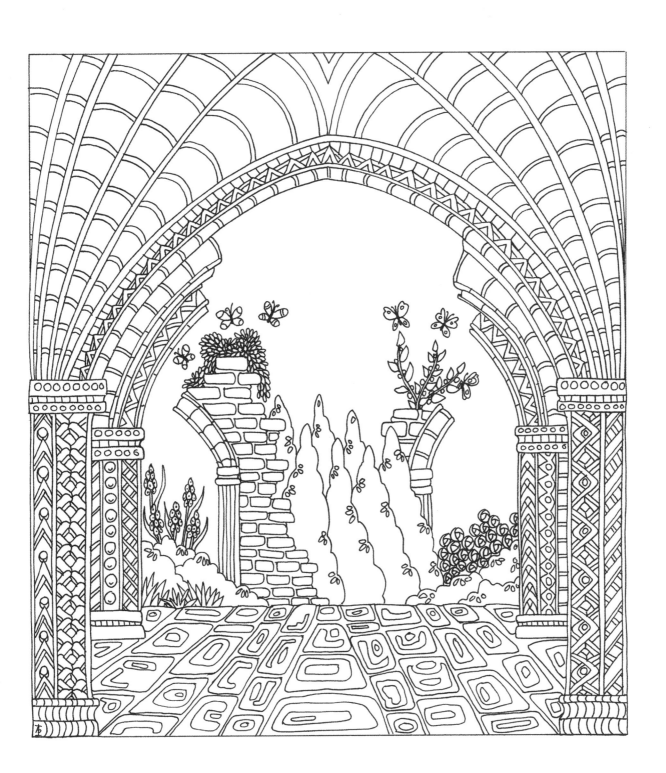

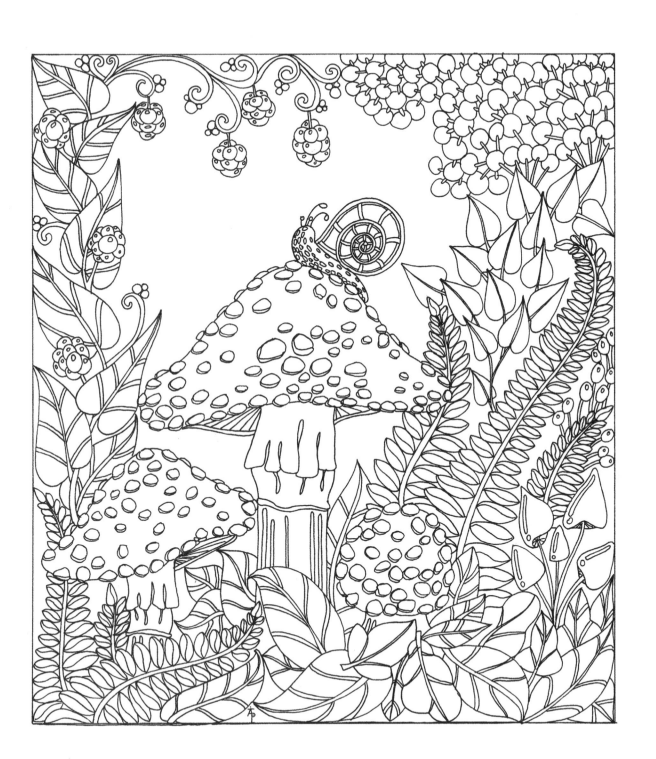

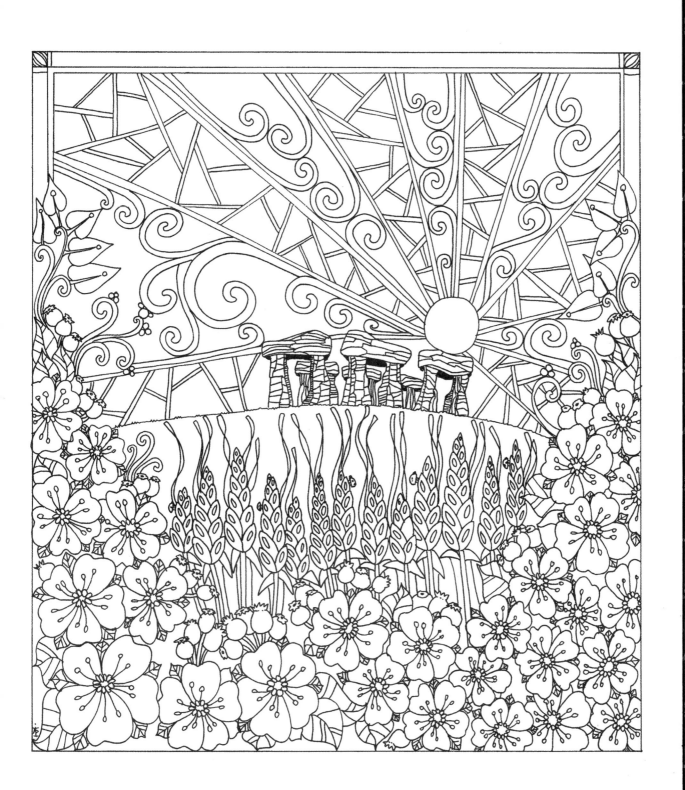

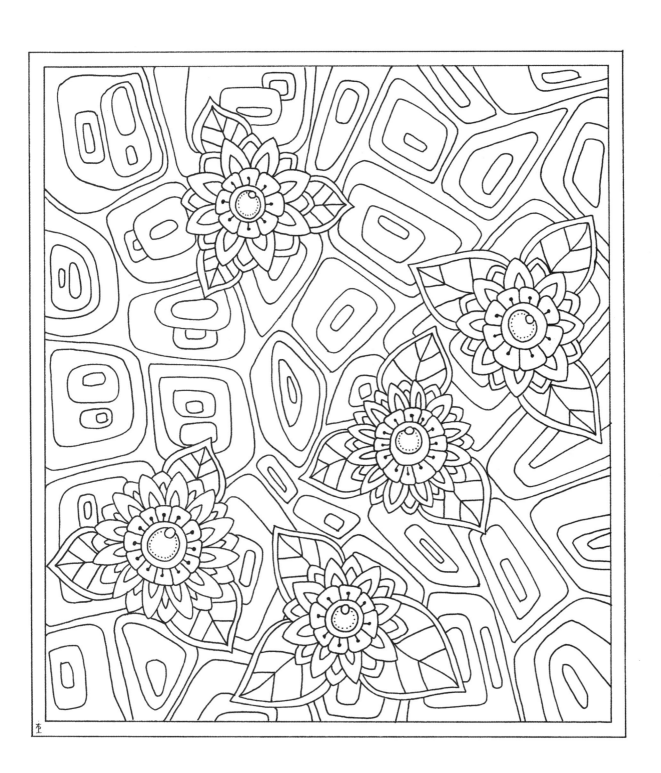

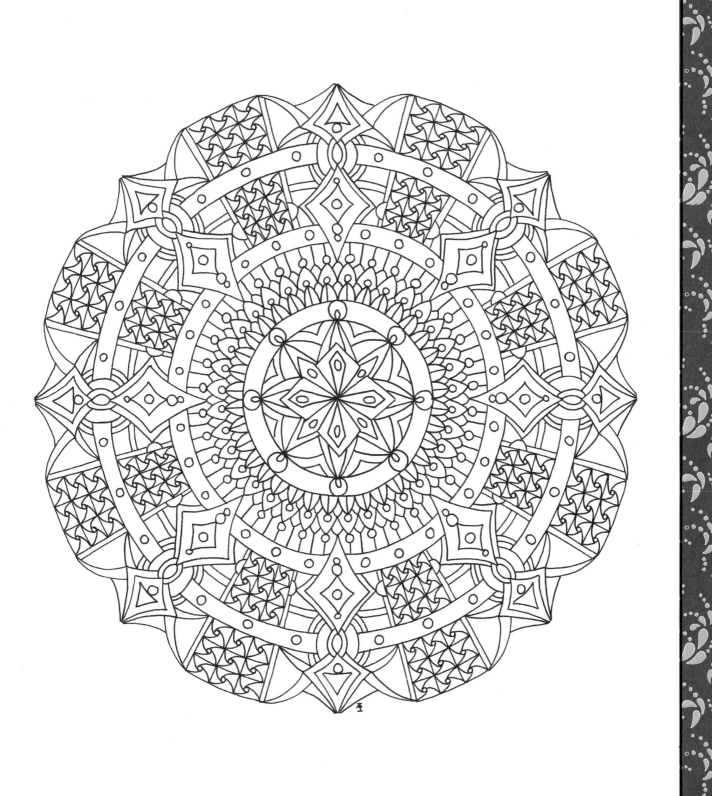

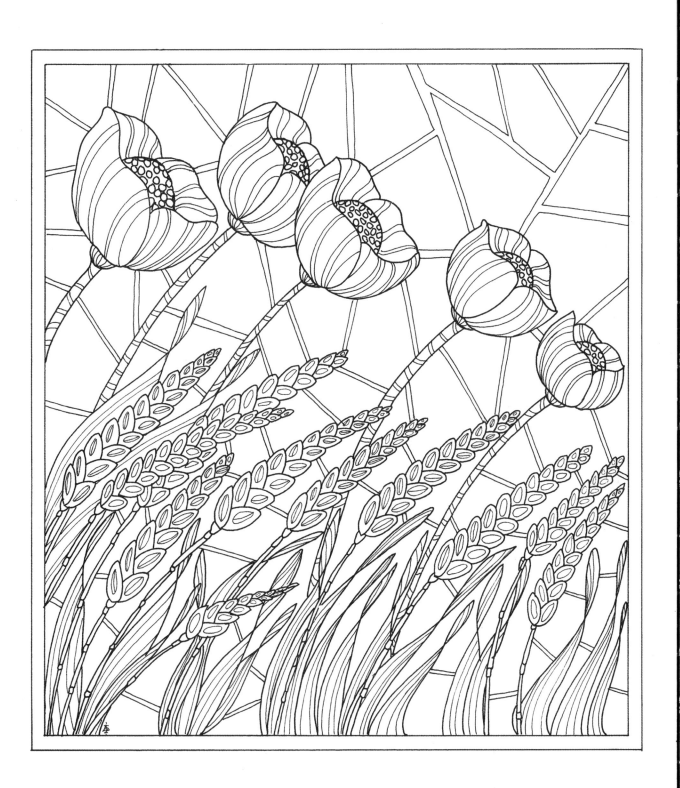

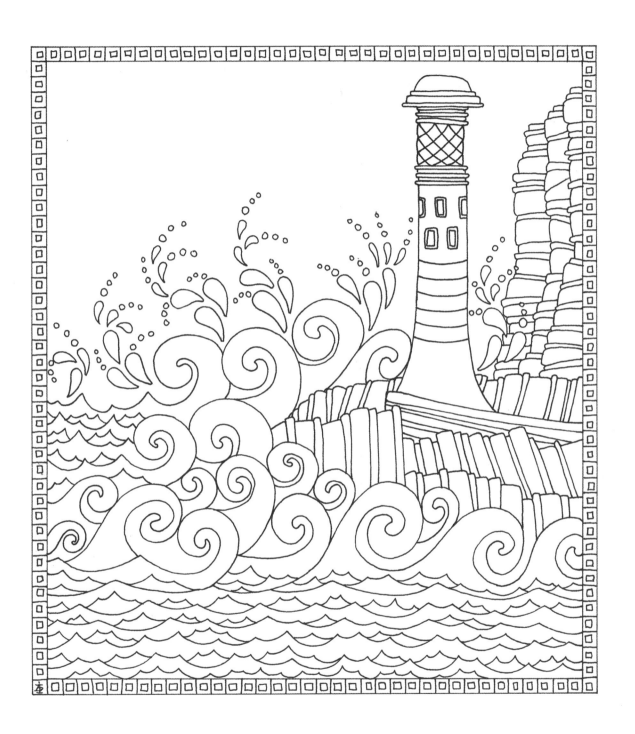

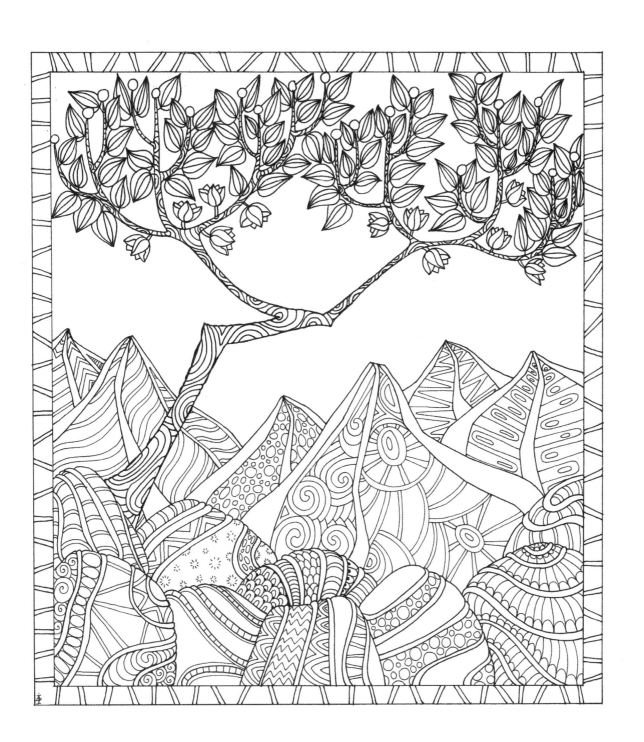

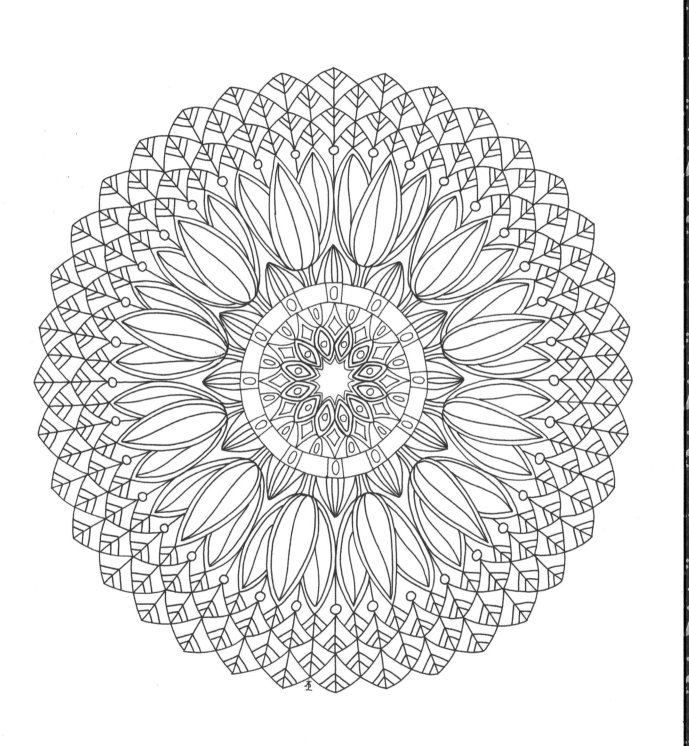

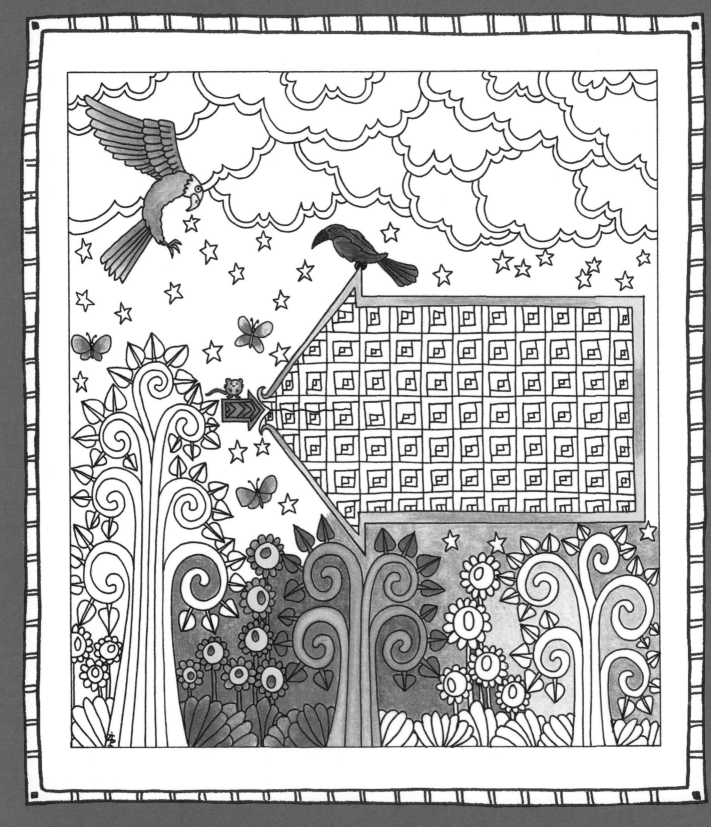

Chapter 4

CONFIDENCE

Fearlessness usually contains a component of confidence—having the assurance that you can prevail over that which seems intimidating or even impossible. Sometimes confidence derives from having experience or training that gives you the skills for being successful; other times, it is the internal certainty in knowing that even if you're experiencing something in an uncharted territory, you can do your best and even succeed at it. Knowing where your confidence lies is valuable knowledge, but equally important is understanding where it may be lacking and finding ways to develop a greater sense of confidence, which may come from guidance, mentoring, exposure to those areas, or education. Being sure of yourself can make all the difference in handling new and repeat challenges successfully and fearlessly. The following images relate to confidence through natural, geometric, scenic, and metaphorical schemas, including illustrations of flowers, even-numbered mandalas (such as stars), scaling mountaintops, and going against the flow. A blank panel is included at the end of the chapter to encourage you to draw and color an image that inspires confidence in your life.

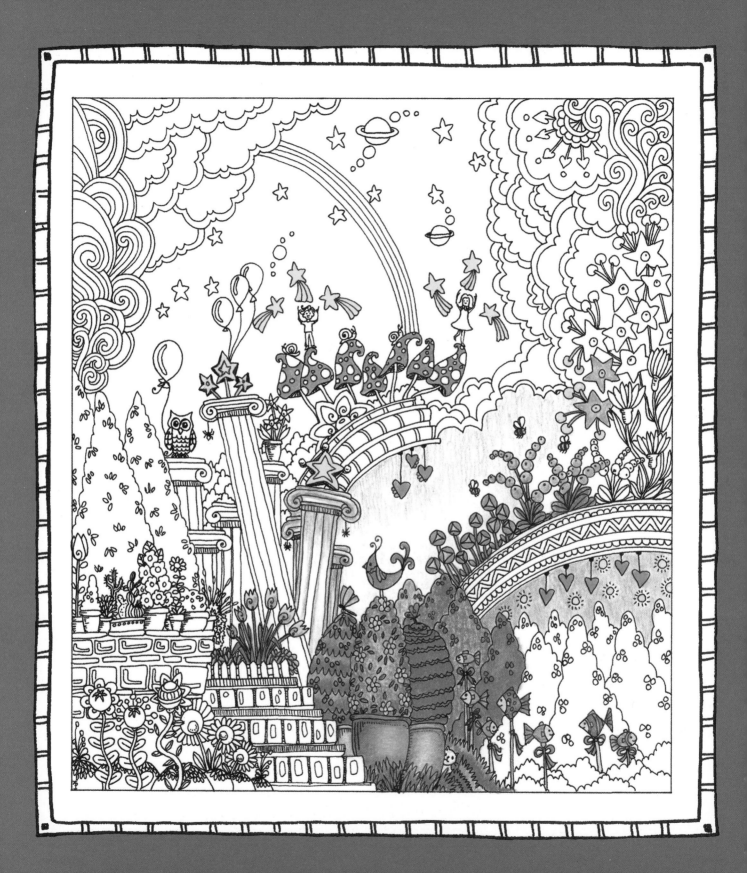

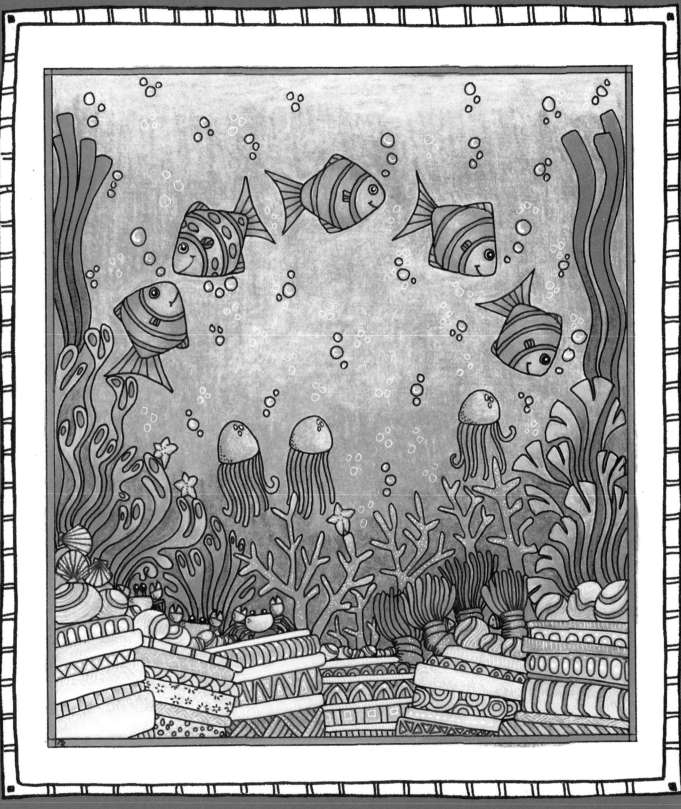

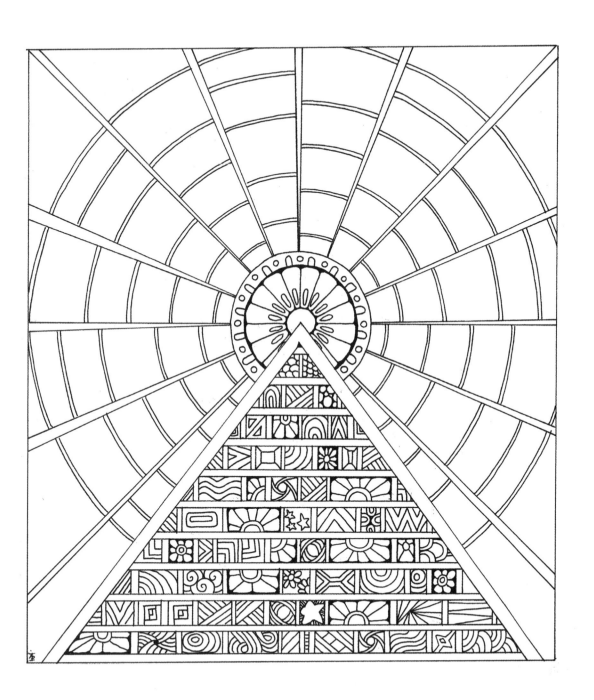

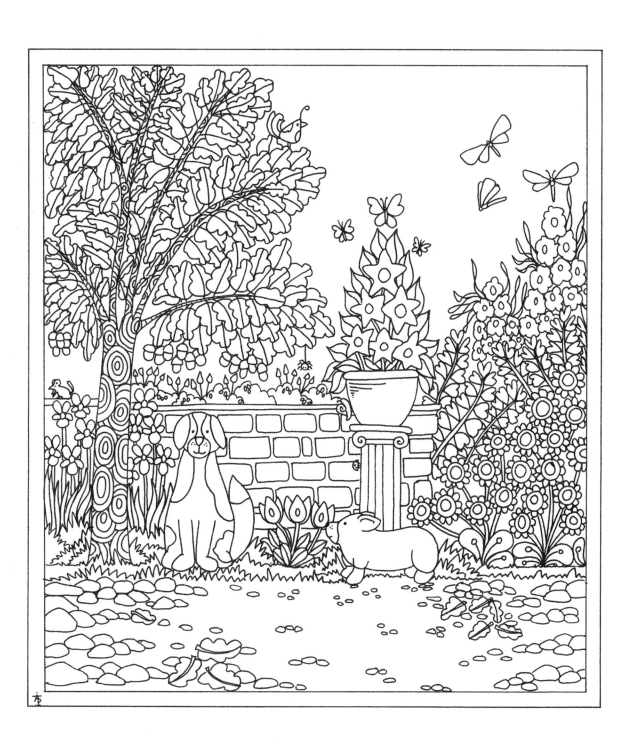

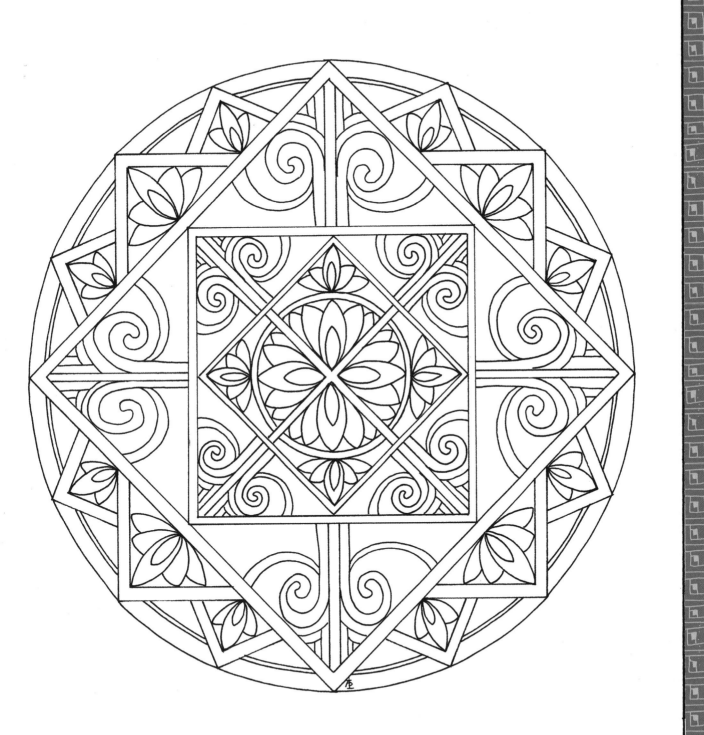

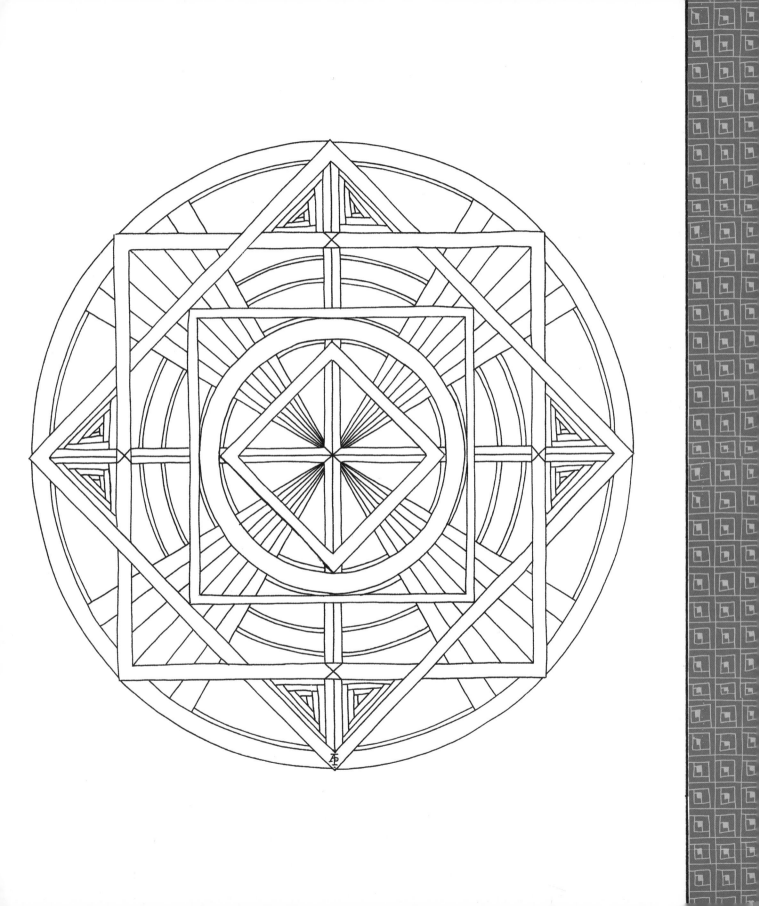

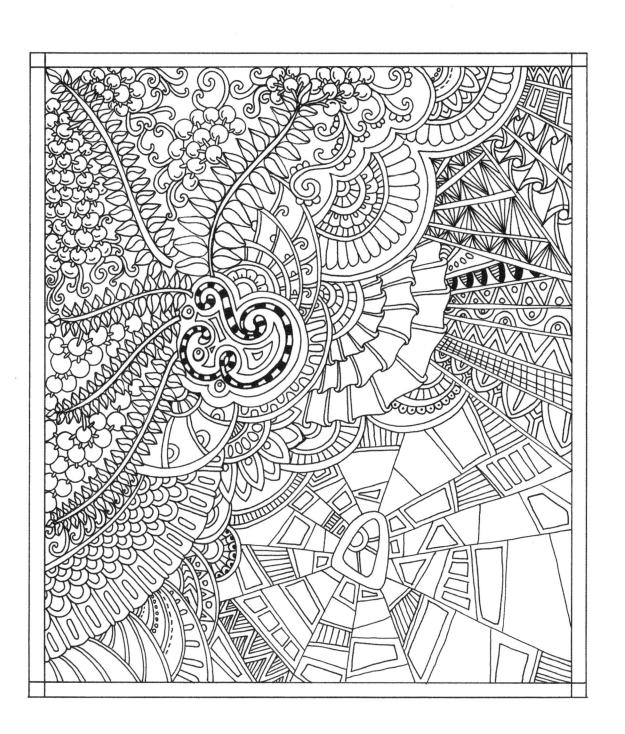

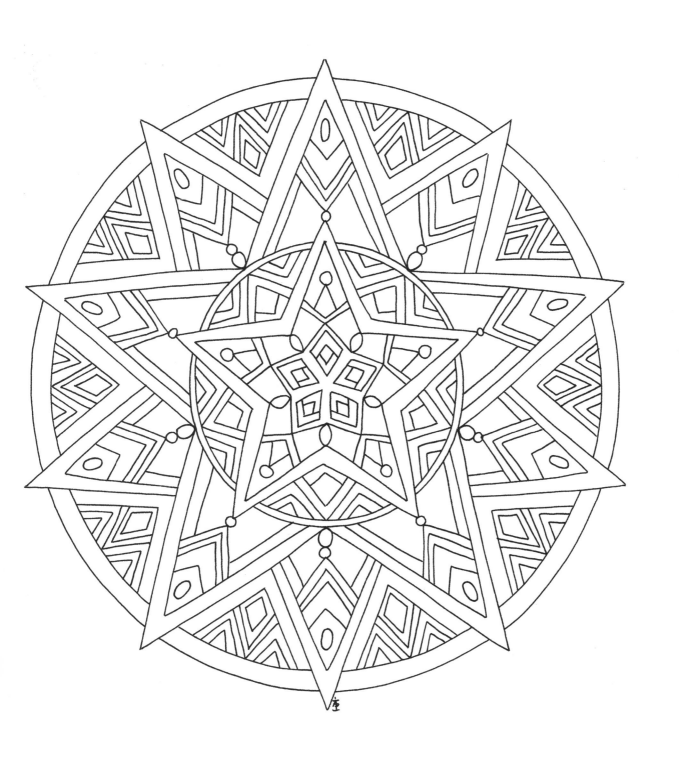

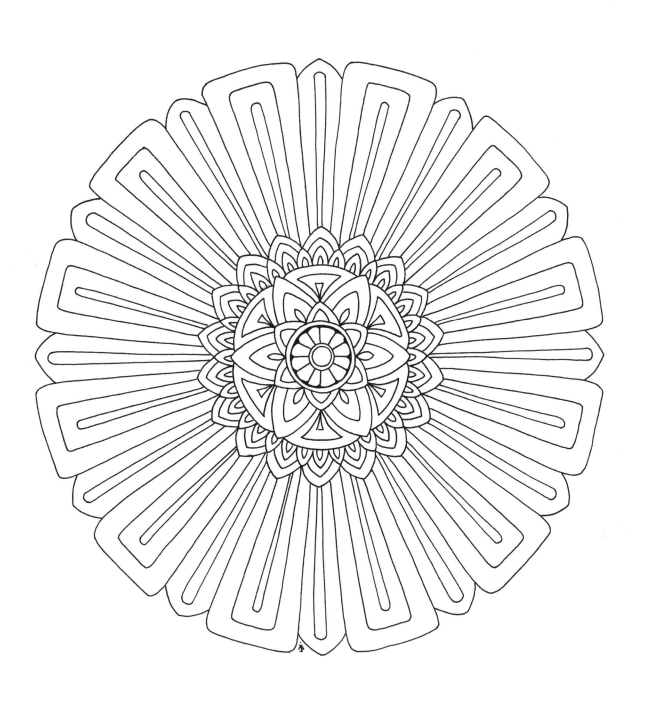

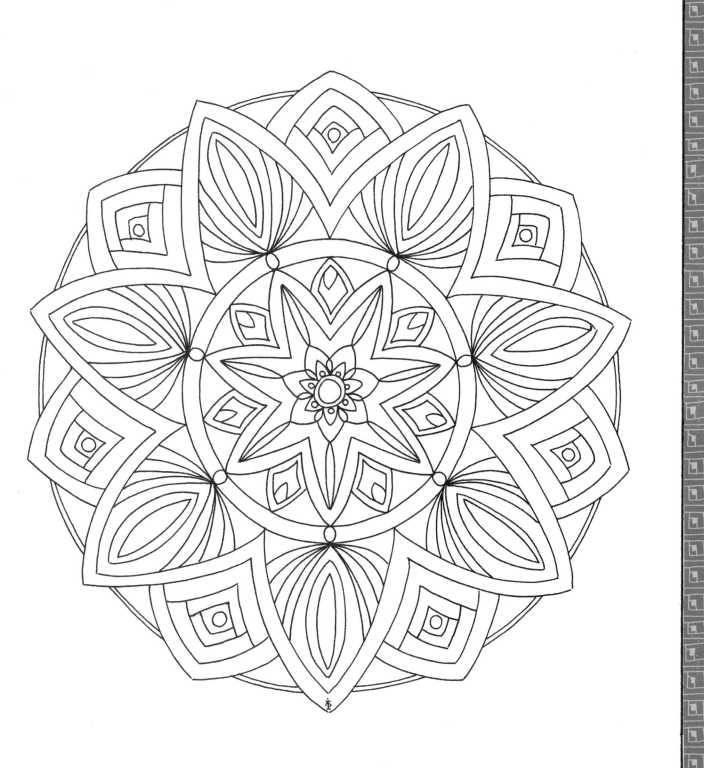

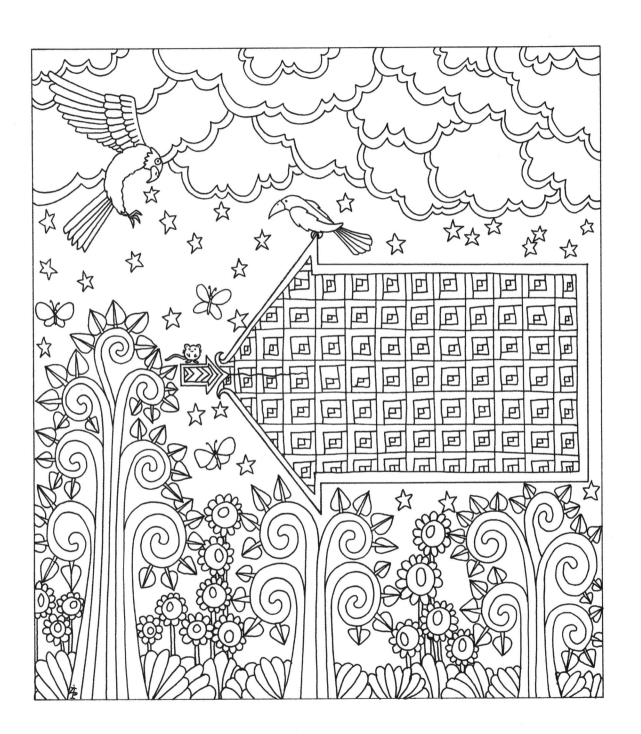

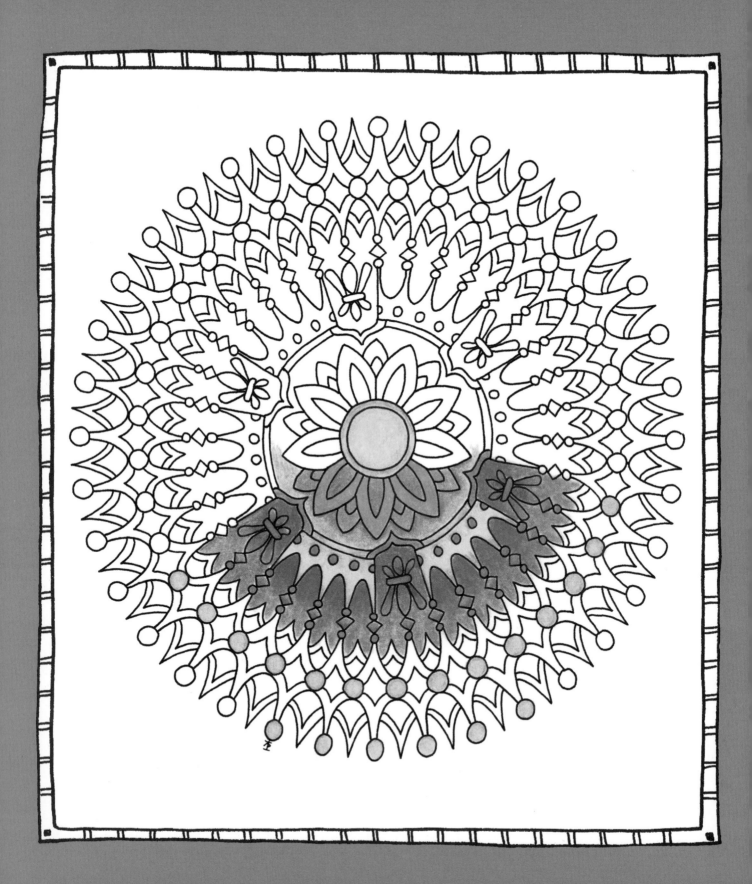

Chapter 5

POWER

There is a certain amount of power that comes with being fearless. When we face and then overcome a challenge successfully, it gives us a sense of power that can, in turn, help perpetuate facing future situations without fear. Having a balanced and healthy sense of empowerment makes us feel more equipped and capable of handling whatever may come our way, whether it is by choice or by happenstance. Though power can be bestowed externally, such as when one gets a job promotion, internal sources of power are the most constant and motivating, and help us press forward and be successful. Being empowered by encouragement, previous successes, and support from others leads to more self-assuredness, which then can foster a greater sense of fearlessness in our daily lives as well as in extraordinary circumstances. The following images figuratively and symbolically relate to images most associated with power, including crowns, headdresses, mighty animals, and impressive structures. A blank panel is included at the end of the chapter to encourage you to draw and color an image that indicates to you.

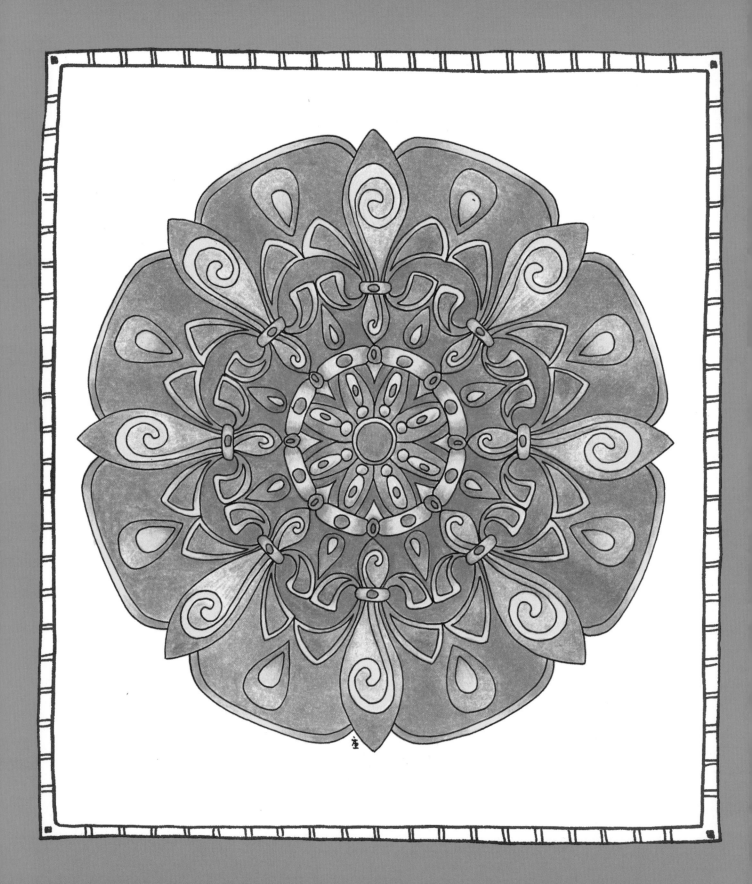

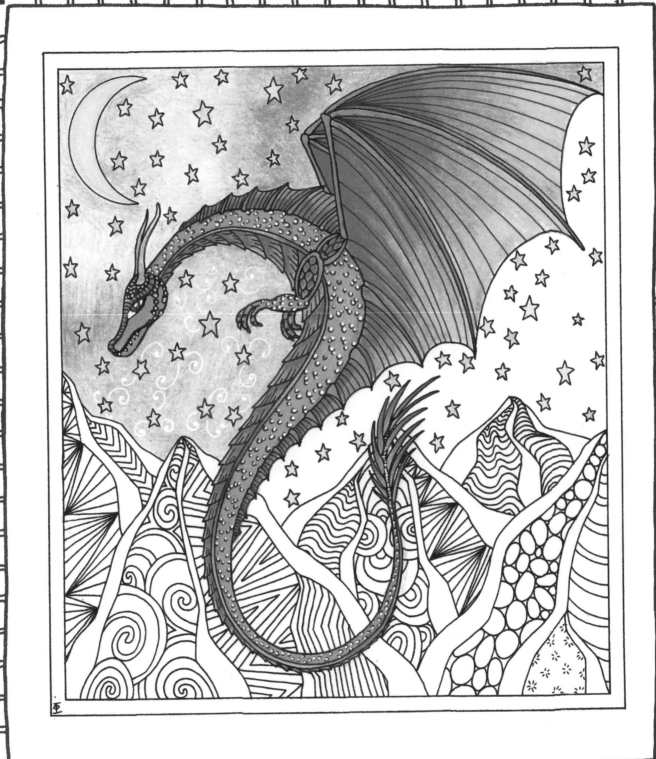

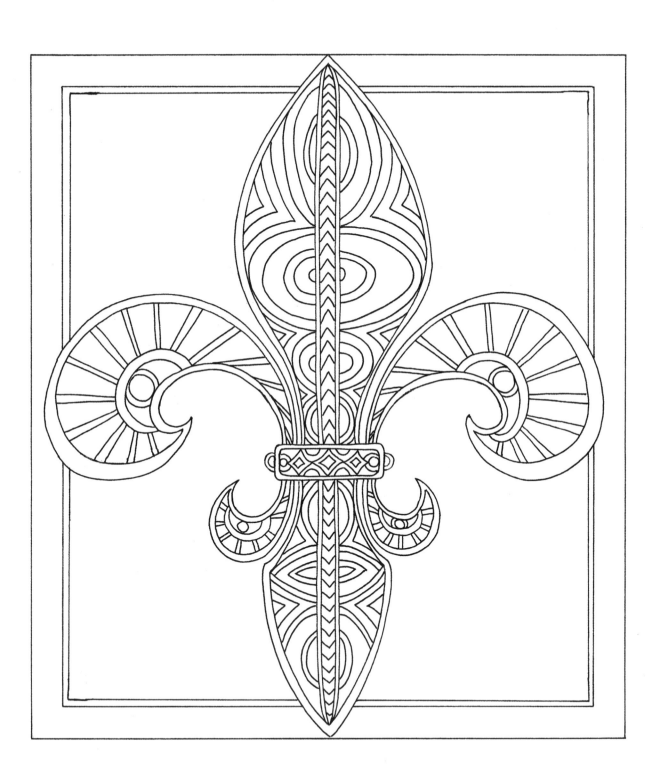

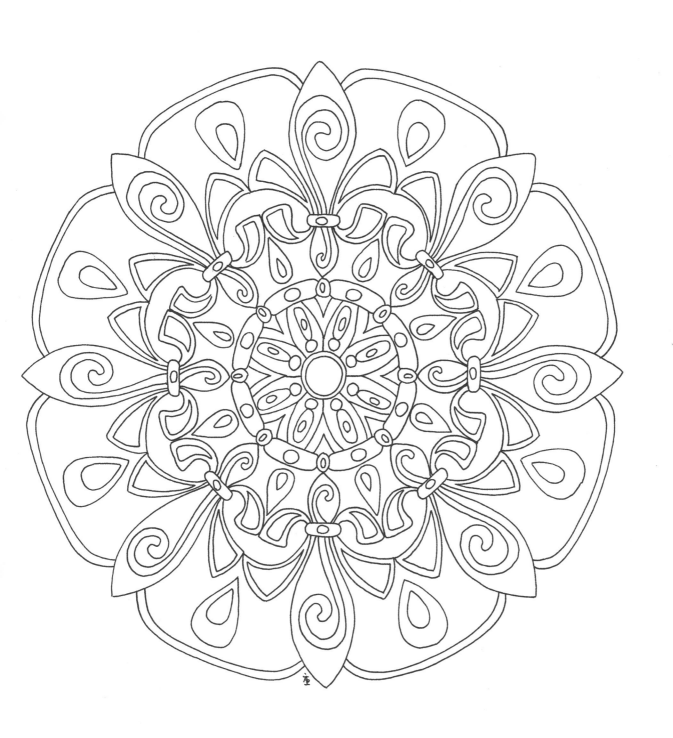

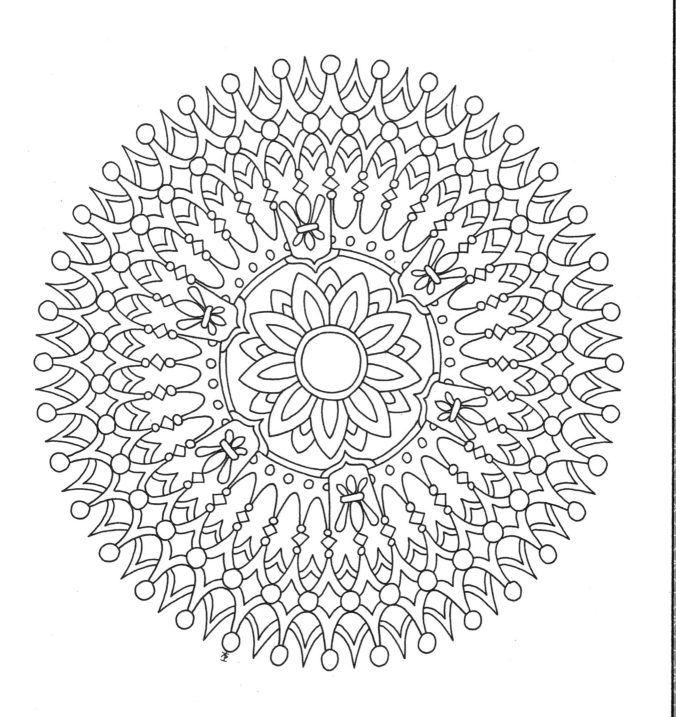

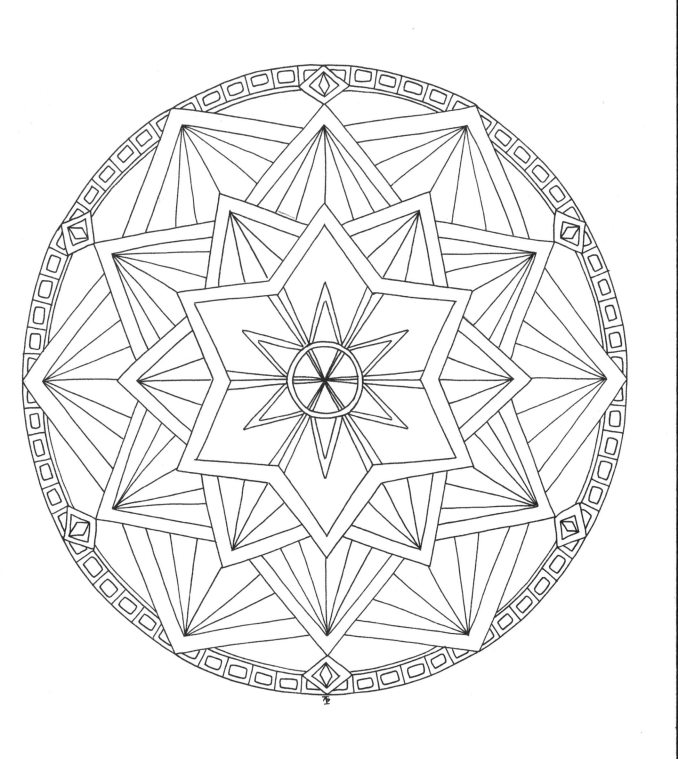

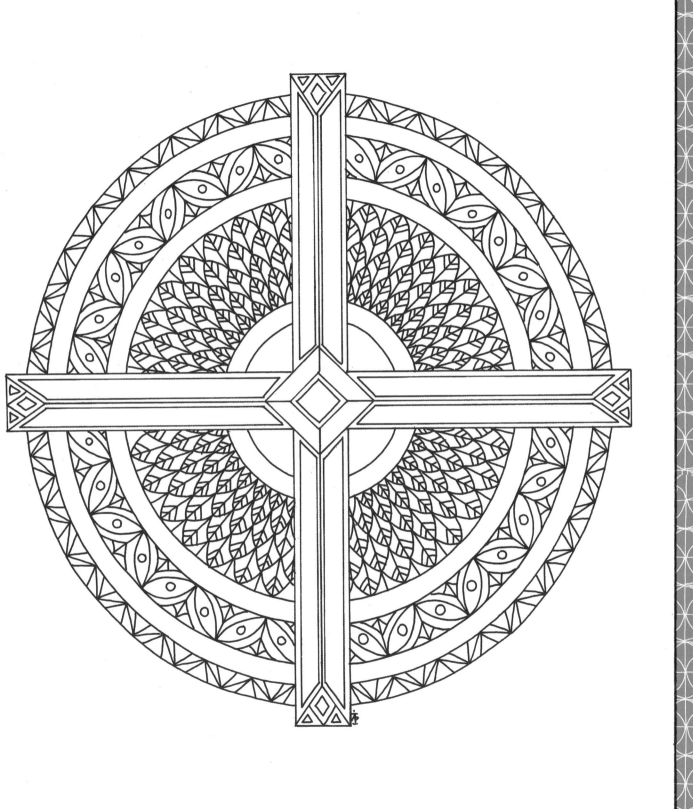

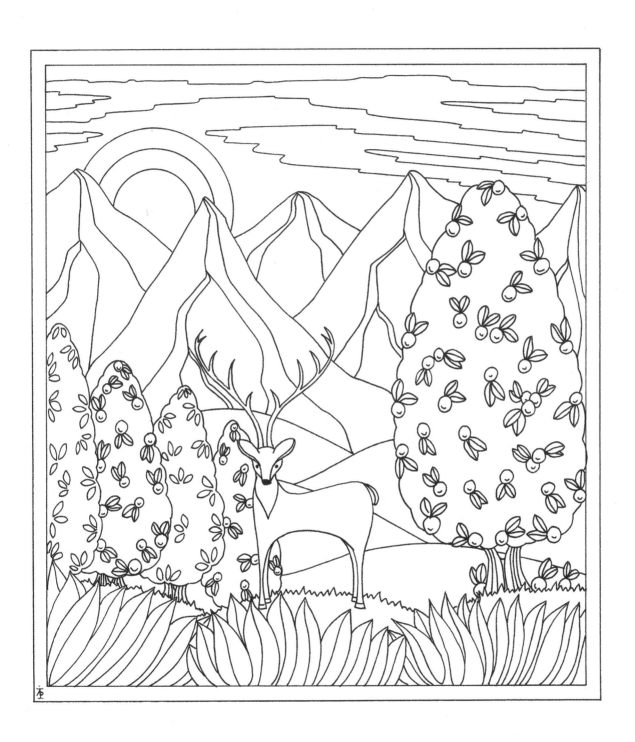

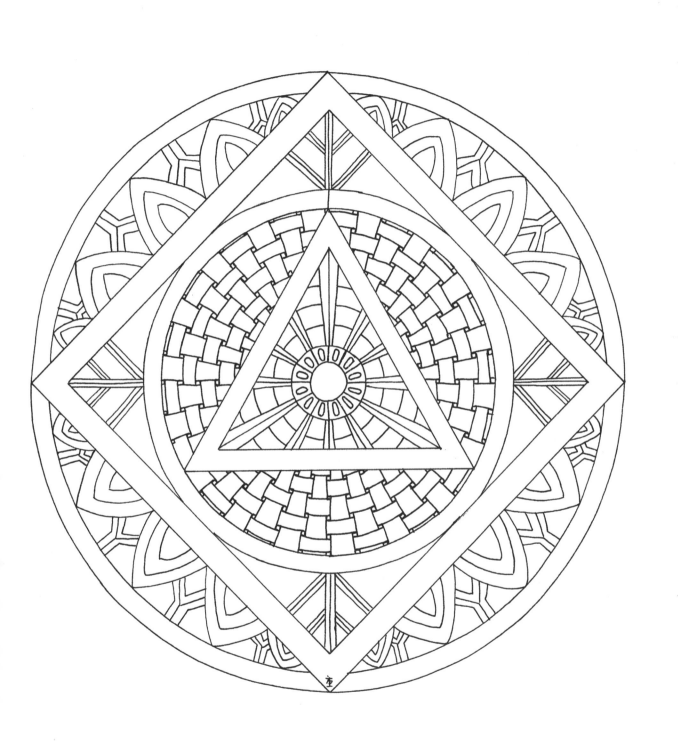

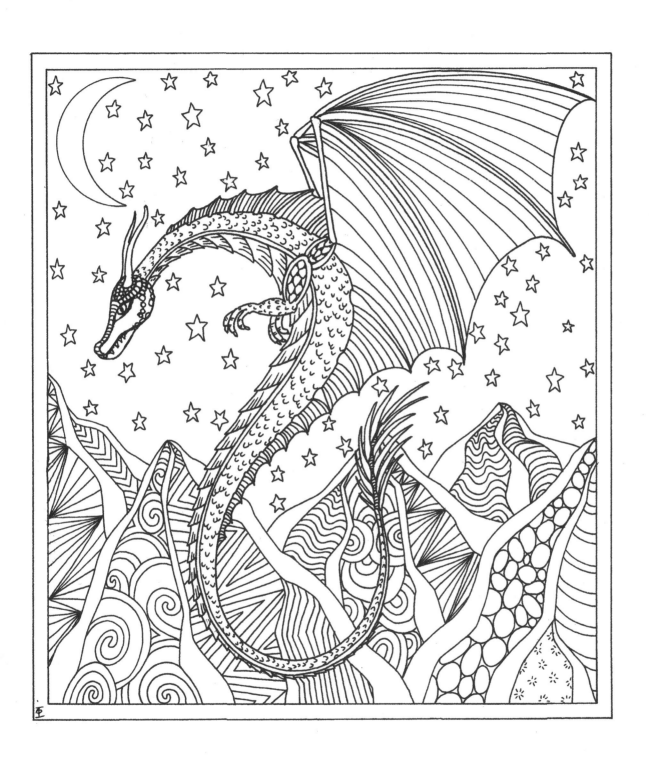

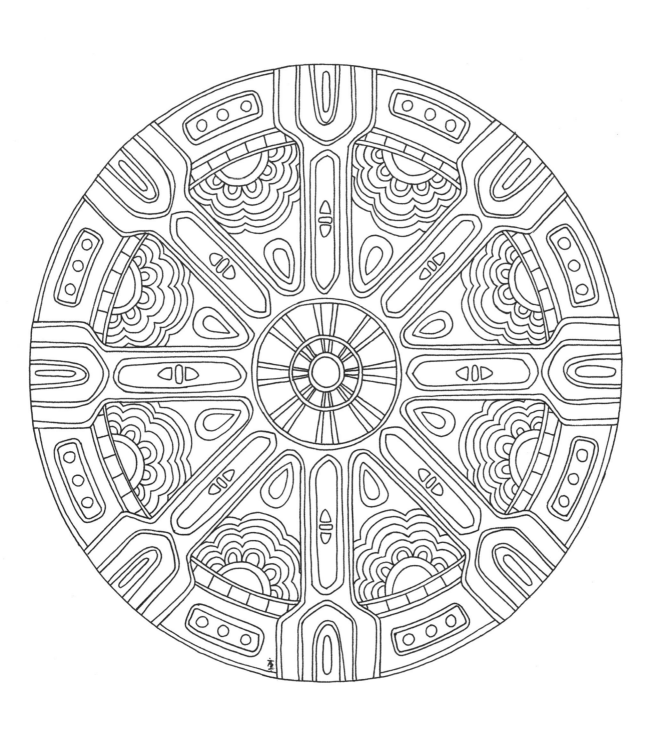

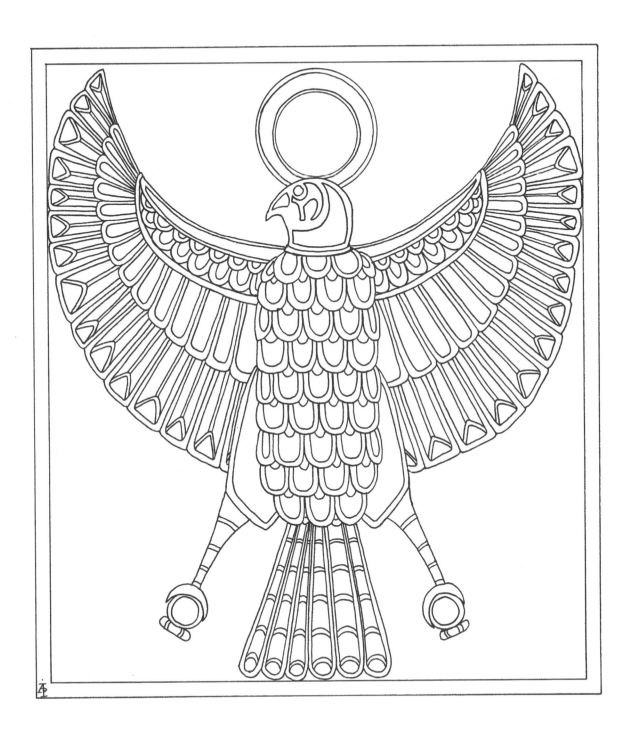

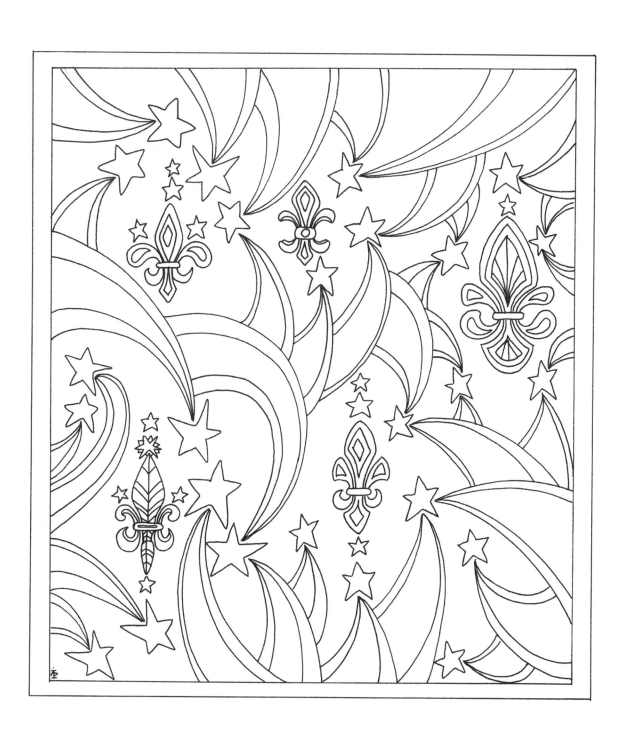

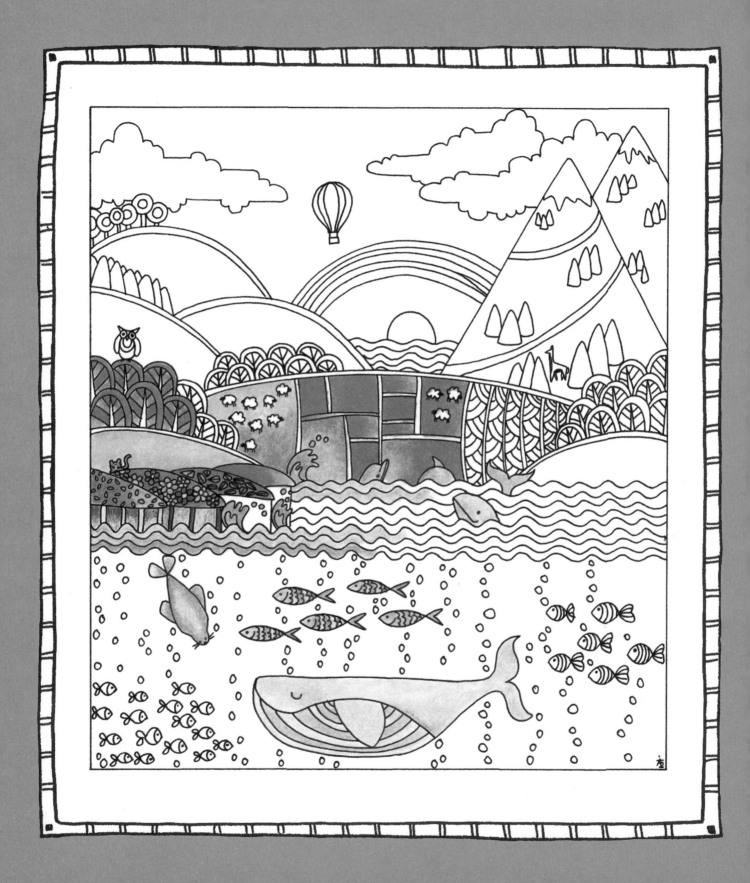

Chapter 6

ADVENTURE

When we are fearless, a sense of adventure can flourish. Conversely, when we have an adventurous spirit, fearlessness can come about as a result of taking healthy risks. Whether it is being spontaneous or trying something new, exercising adventurousness will only help to foster fearlessness. Some people are adventurous by nature and may jump into any situation headfirst, but for many, developing a sense of adventure is built slowly over time by starting small and increasing the amount of risk, novelty, or exposure. Regardless of the approach, the decrease of fear and increase in confidence are often the outcomes of taking appropriate risks. The exhilaration we feel from being adventurous can further reinforce the positive benefits of being fearless so that we are likely to engage in life-enhancing activities and events more often. The following images envision the ways we can experience adventure by pushing us to our furthest limits, including the exploration of remote places and even space. A blank panel is included at the end of the chapter to encourage you to draw and color an image that fosters a sense of adventure in you.

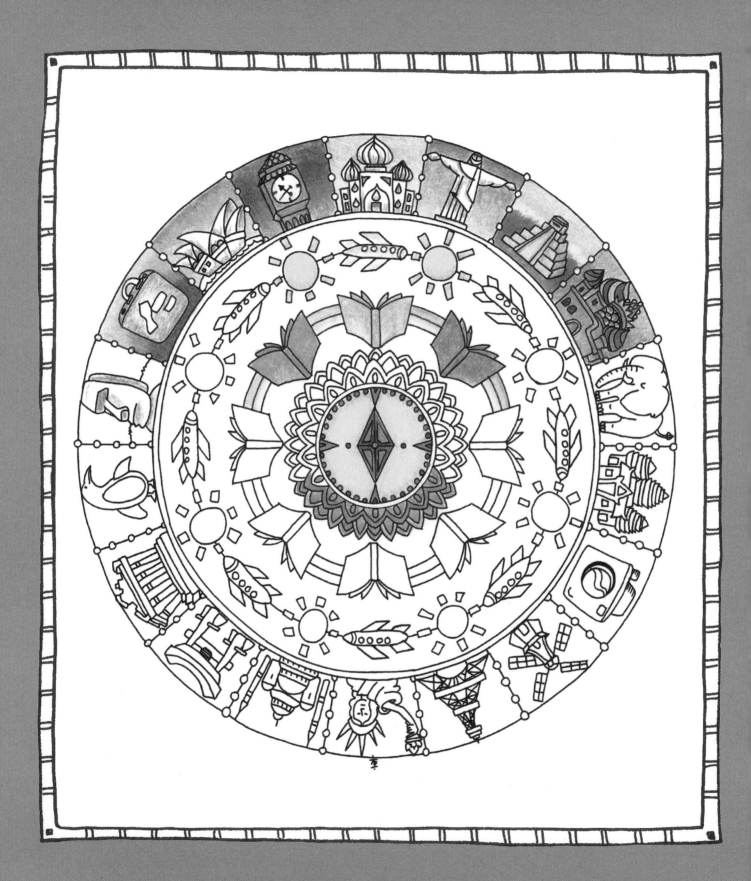

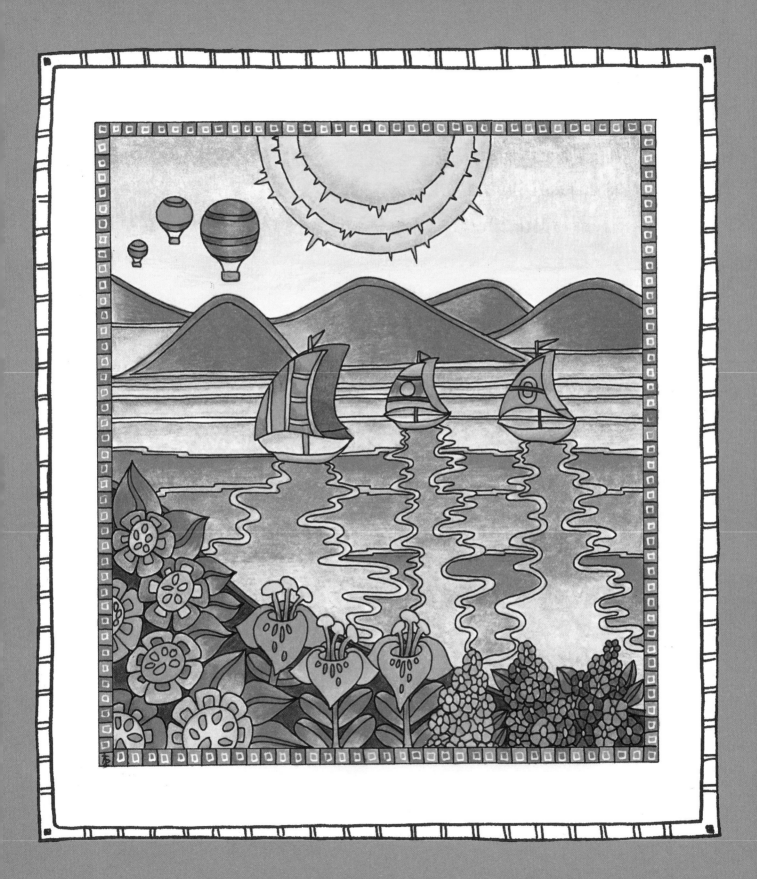

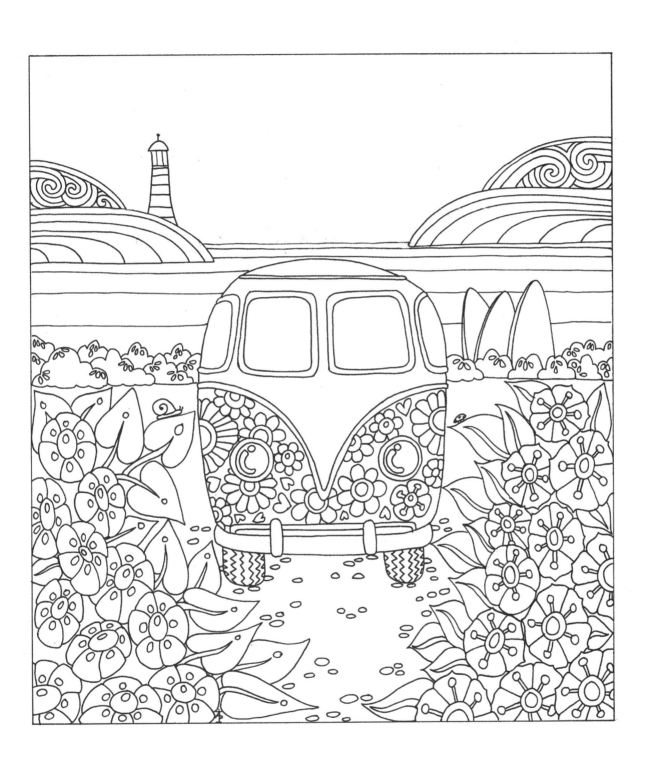

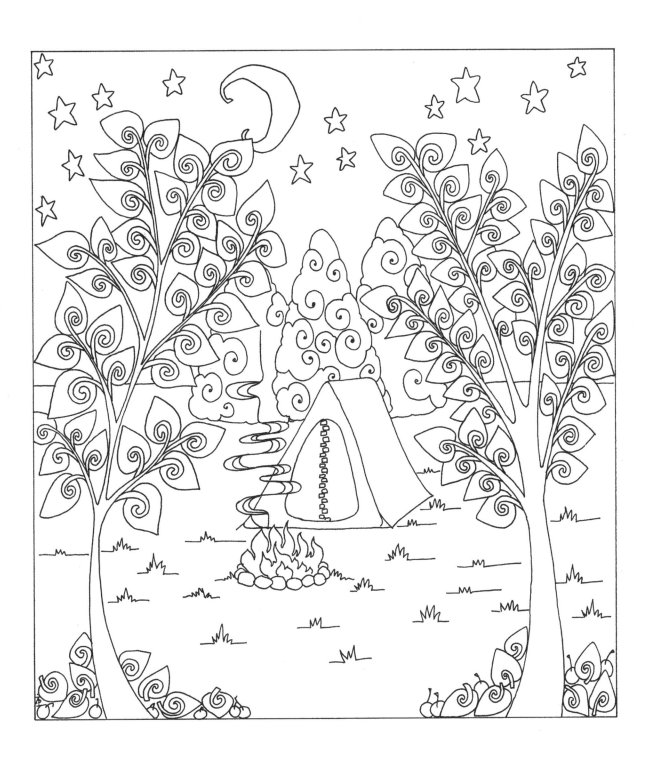

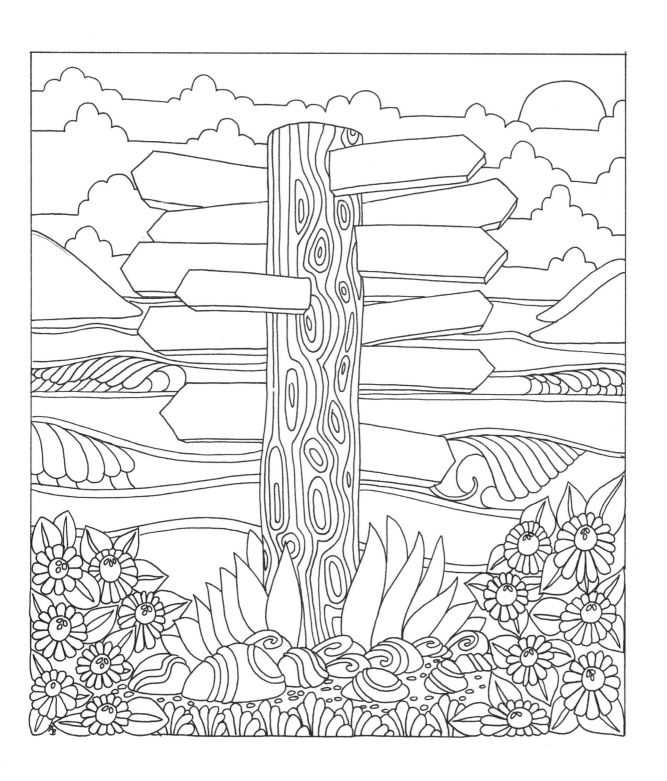

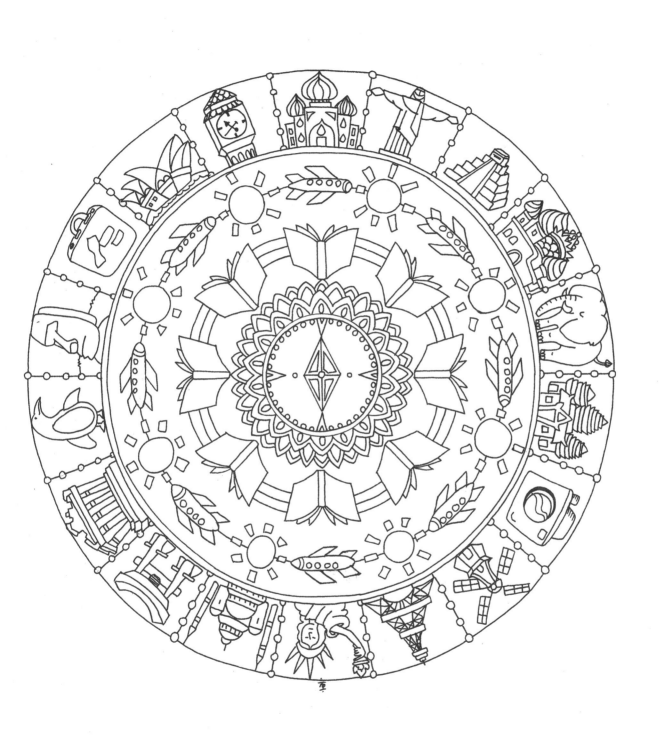

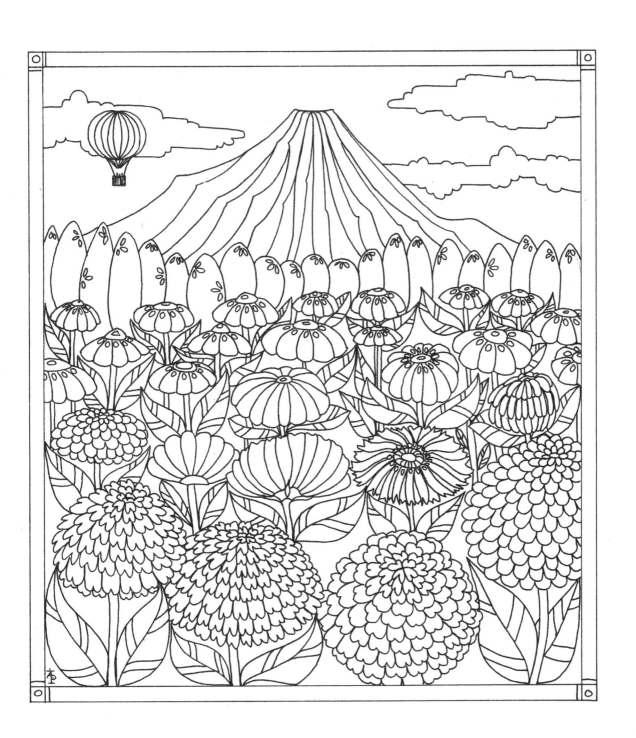

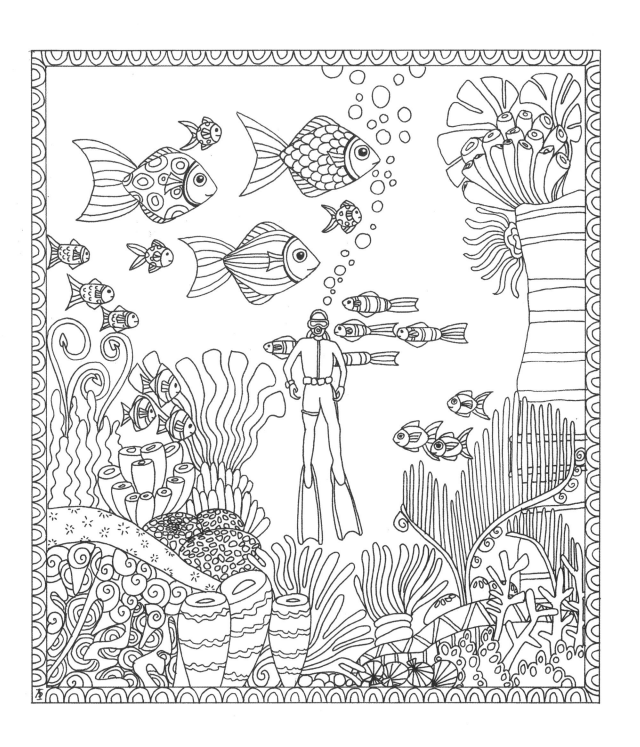

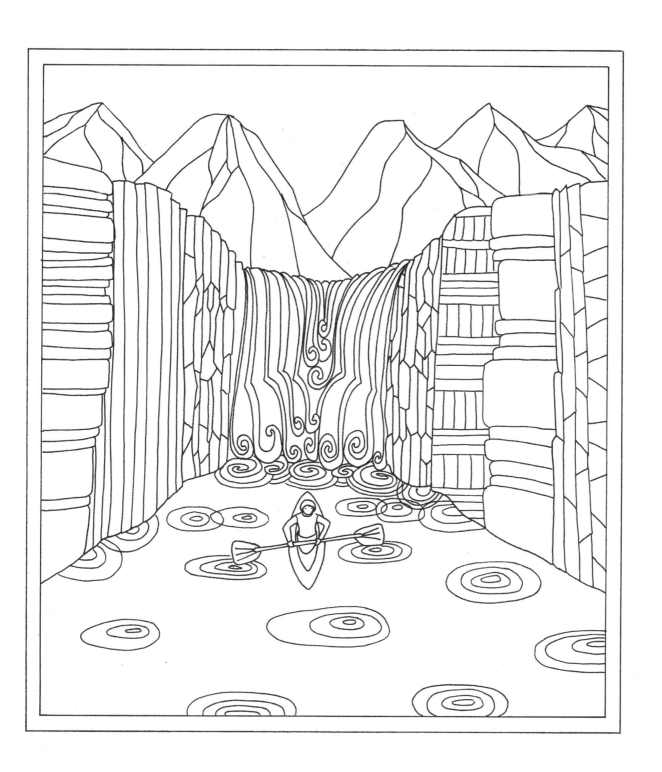

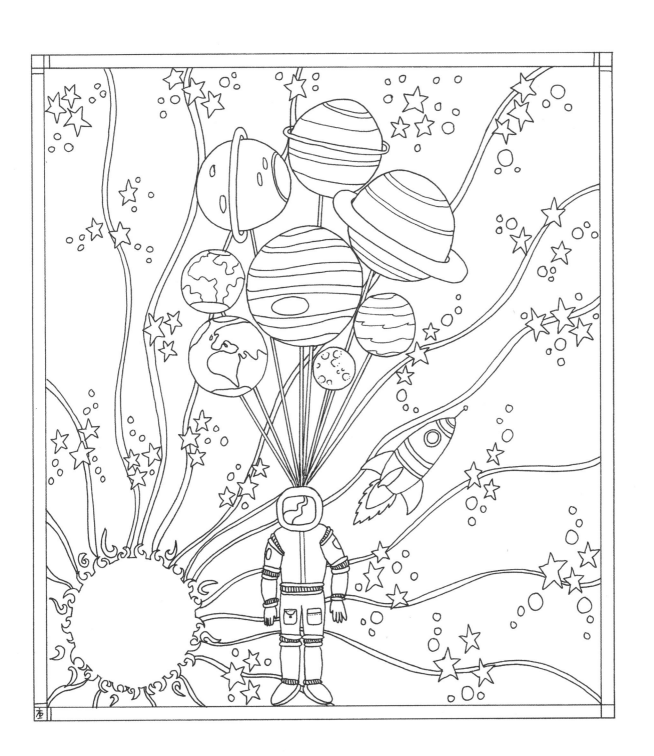

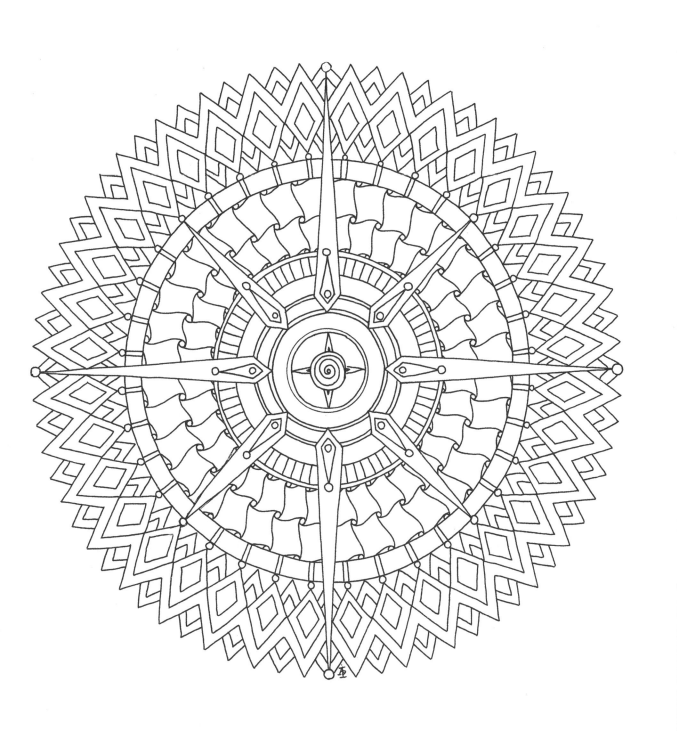

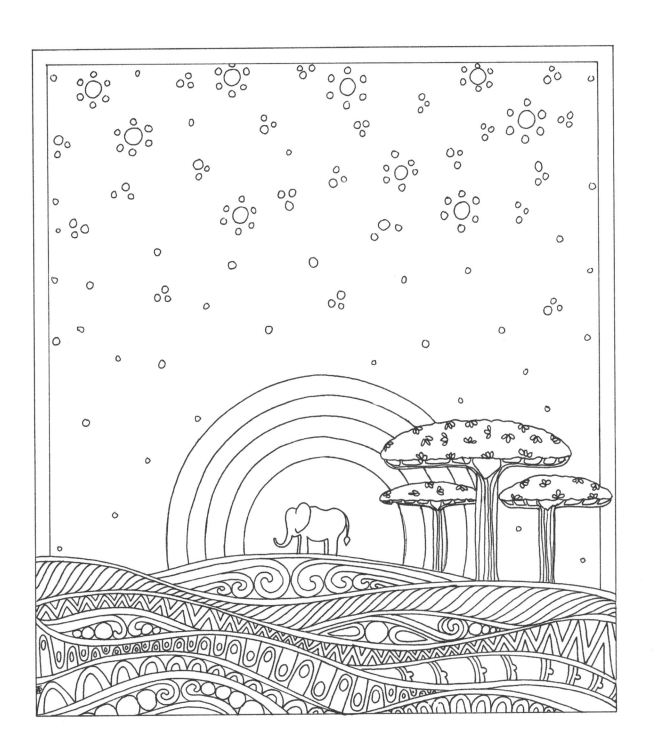

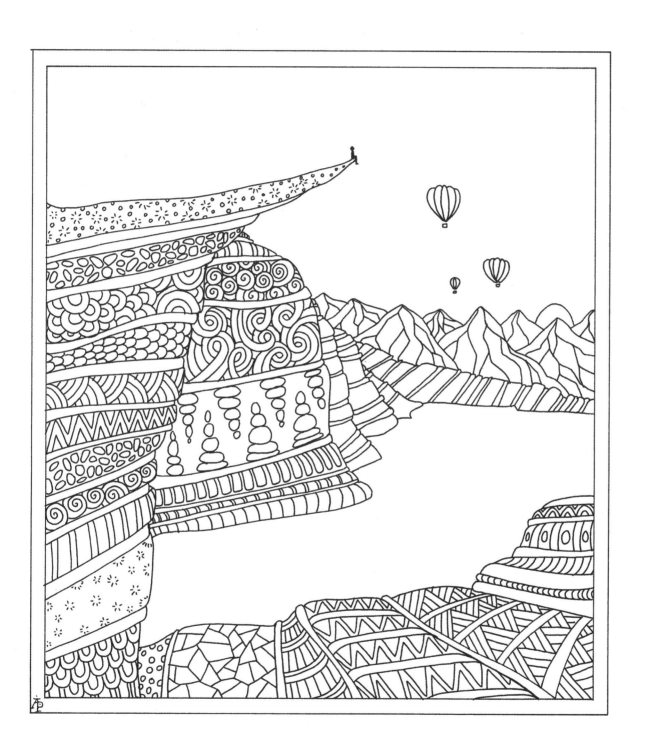

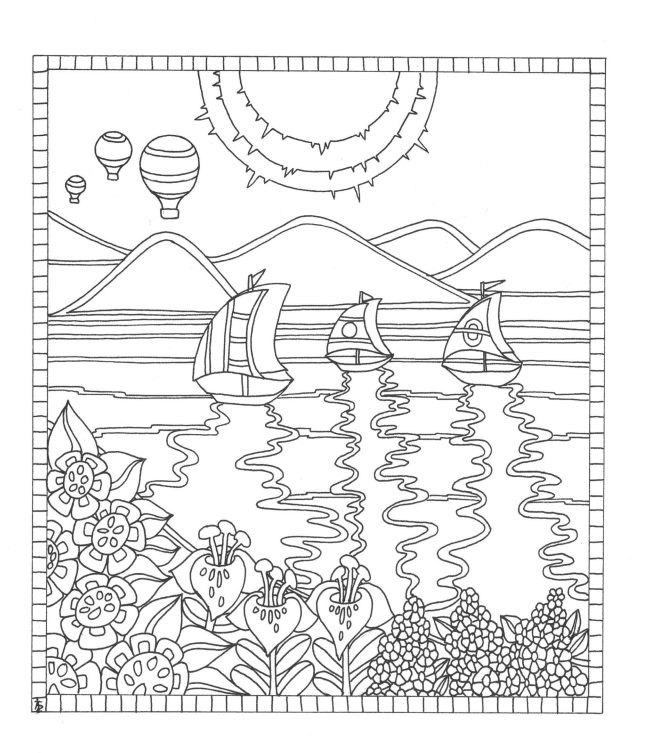

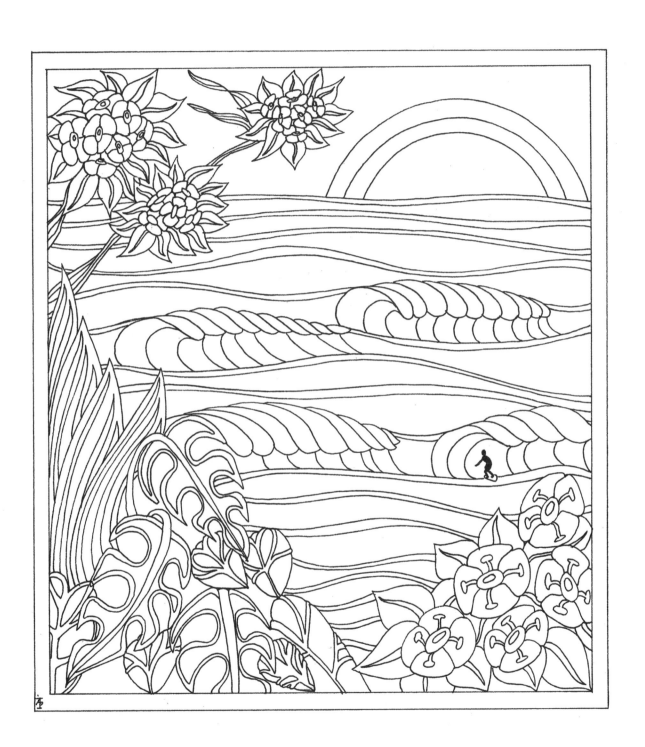

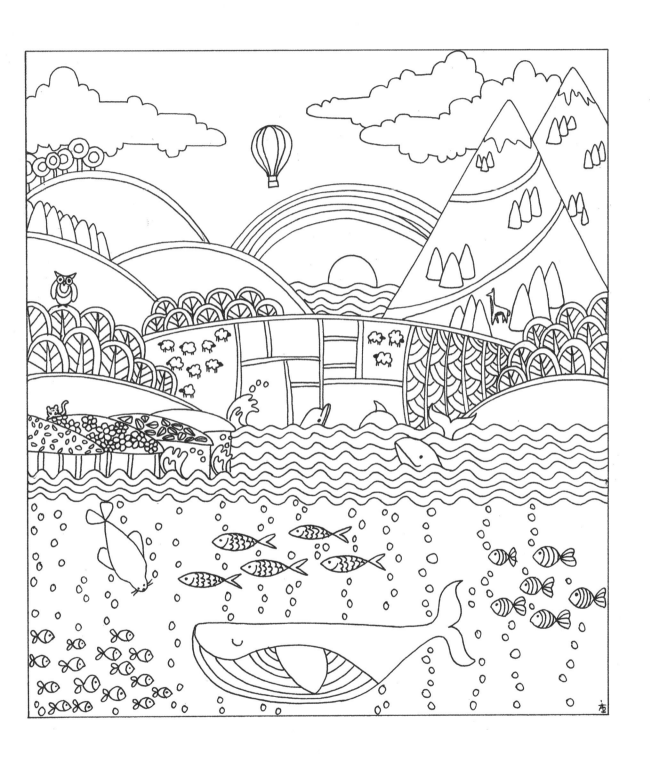

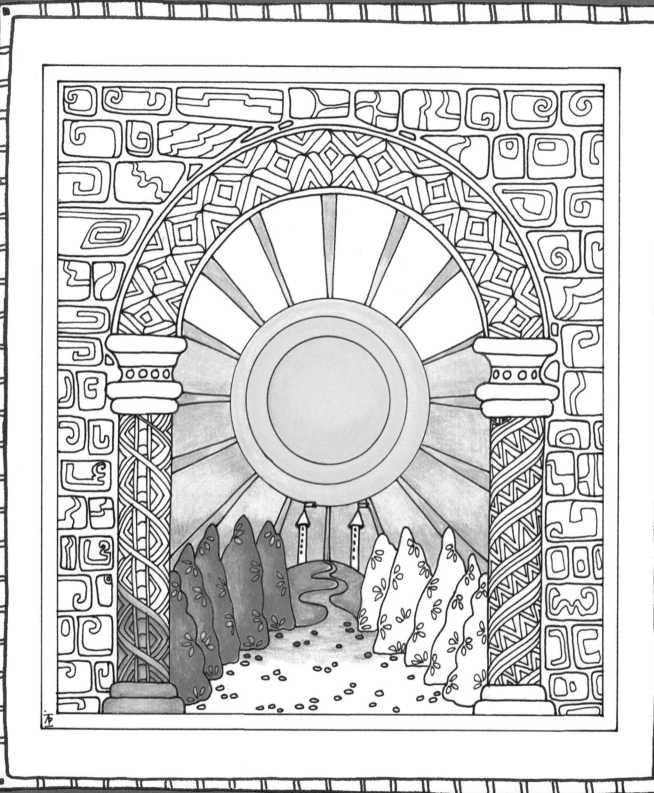

Chapter 7

FREEDOM

If you are not bound by fear, then only freedom can result. As you shed anxiety, worry, self-doubt, and trepidation, there is a burden that is lifted, which allows you to expend your energy elsewhere as well as no longer hold you back from pursuing your hopes and dreams, and even help you to live your everyday life more fully. As you experience freedom from fear, the inhibitions that may have initially prevented you from doing things will fall by the wayside, and as a result, your behavior will be less influenced by fear-based responses. There is a certain comfort in taking appropriate chances, as you become less concerned about the risk of rejection, judgment, or disapproval from people around you (especially those you find intimidating). This brings about a kind of personal freedom that can build a fearlessness within you. The following images focus on elements of freedom that embody the mindset of not being tied down and making the sky your limit, and include portrayals of flying and representations of breaking free from confinement. A blank panel is included at the end of the chapter to encourage you to draw and color an image that sets you free.

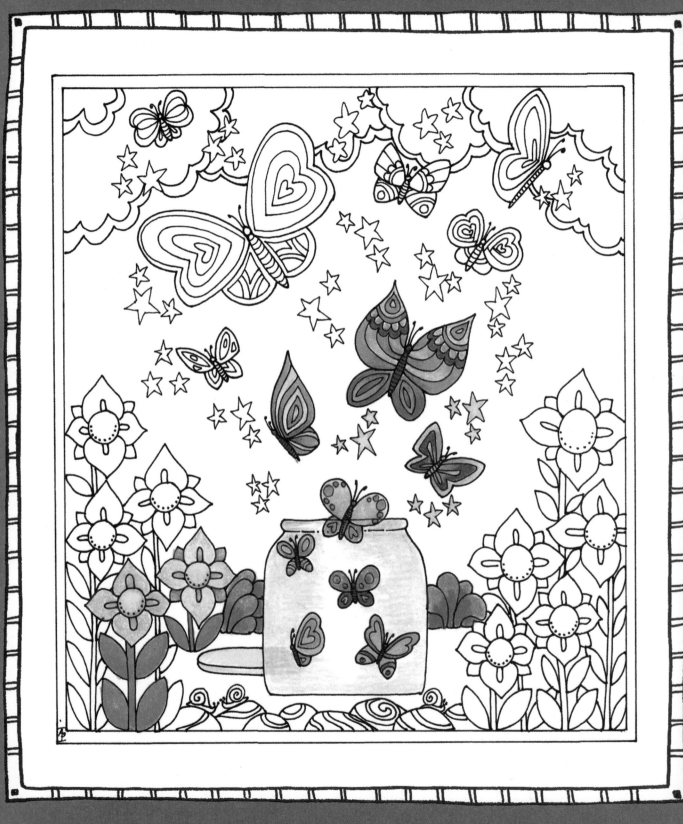

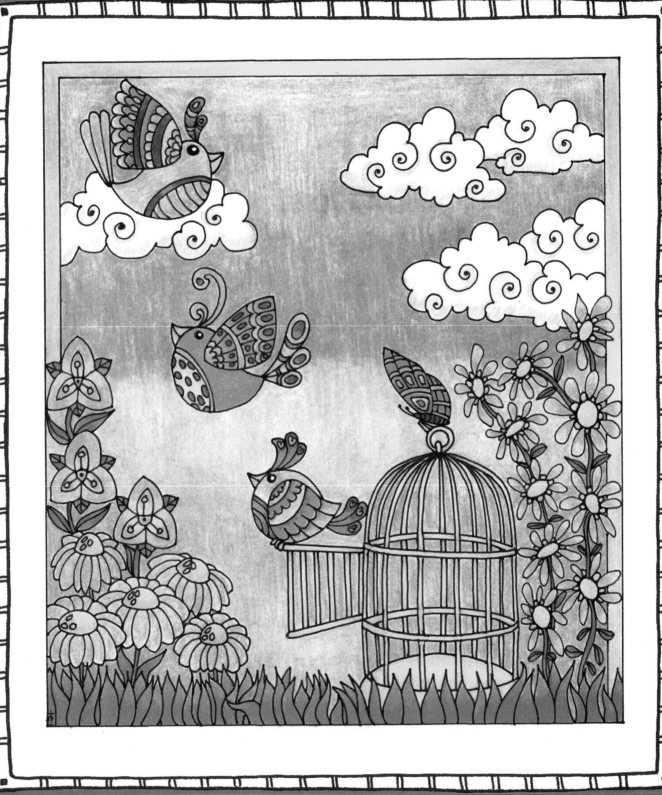

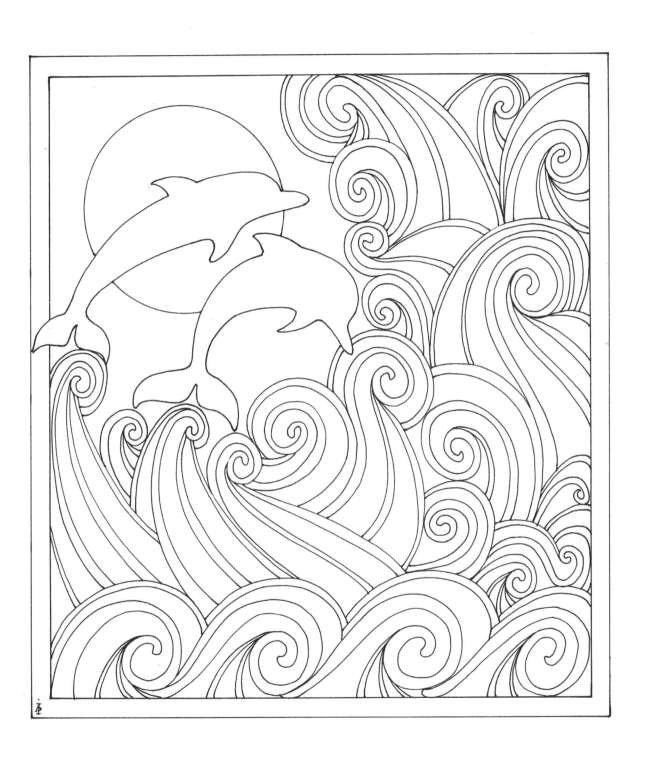

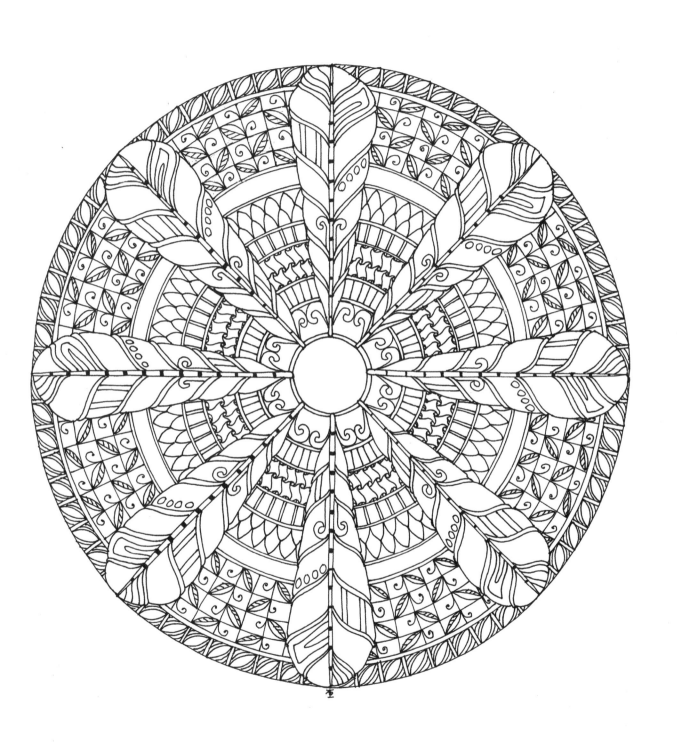

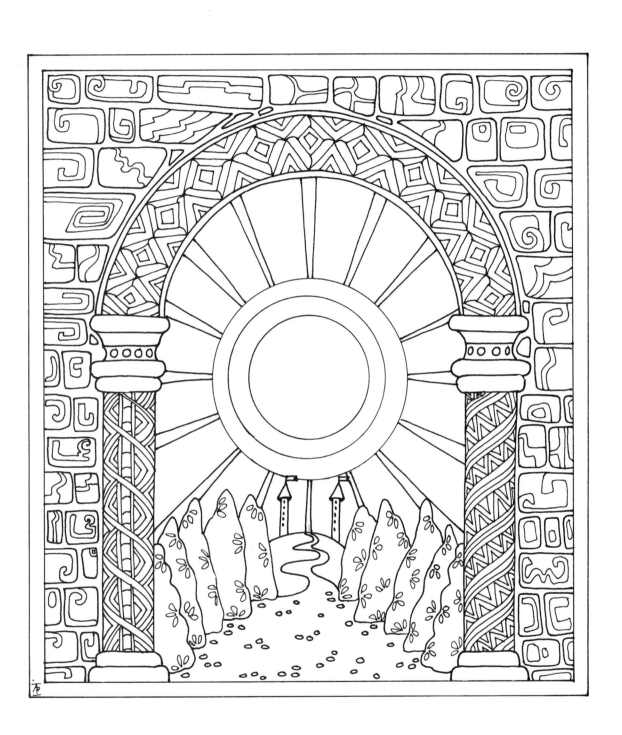

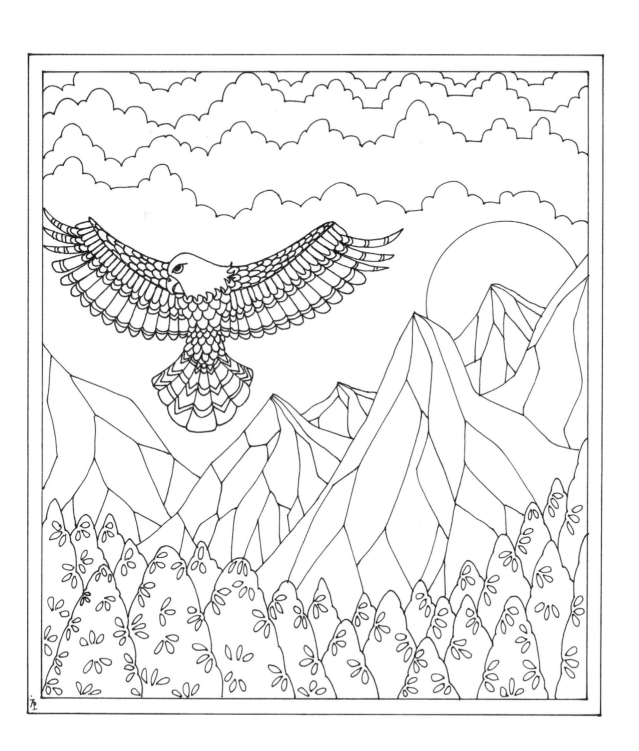

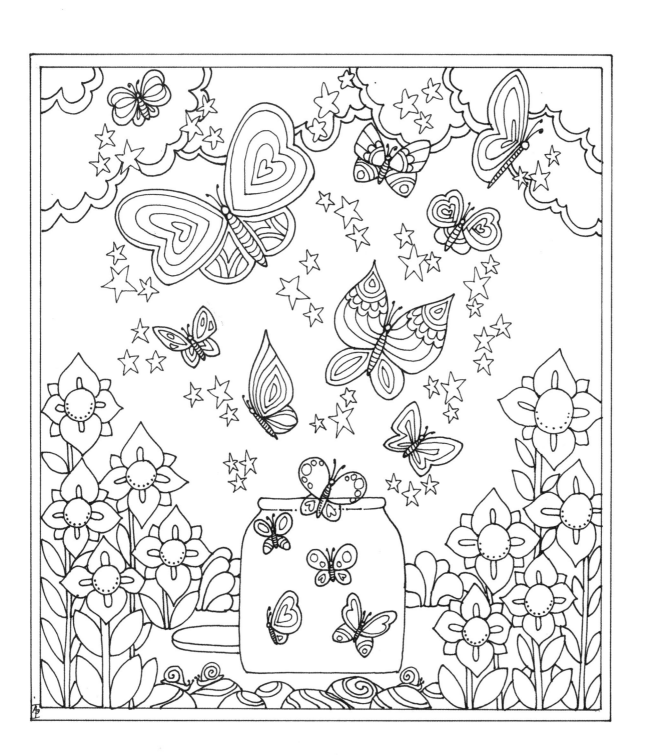

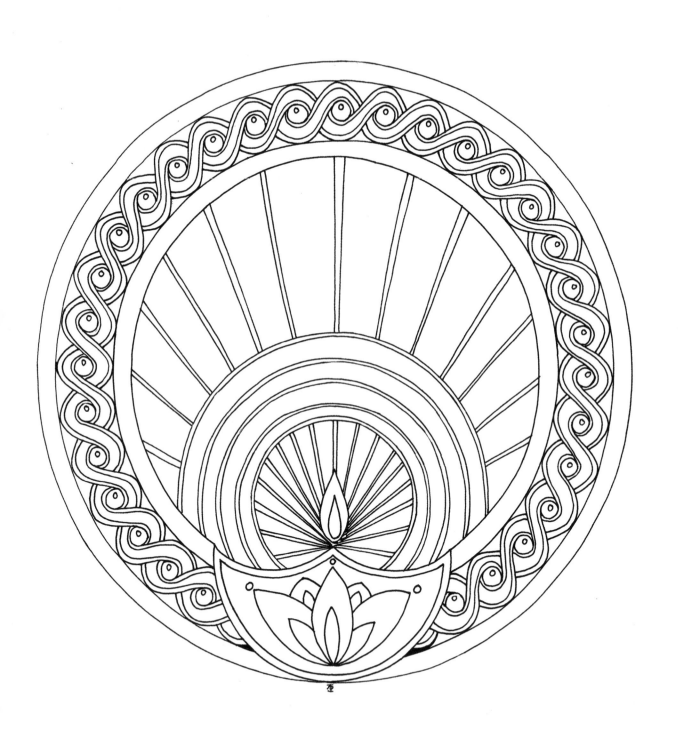

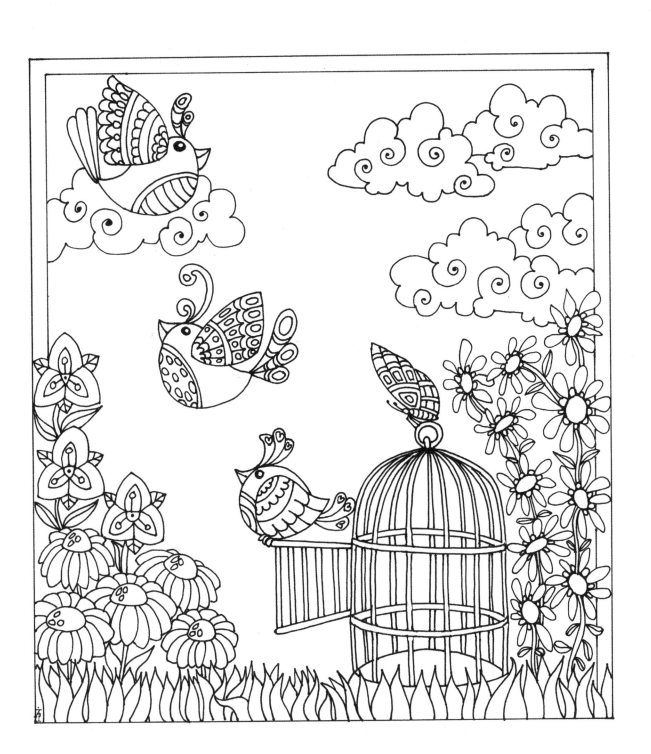

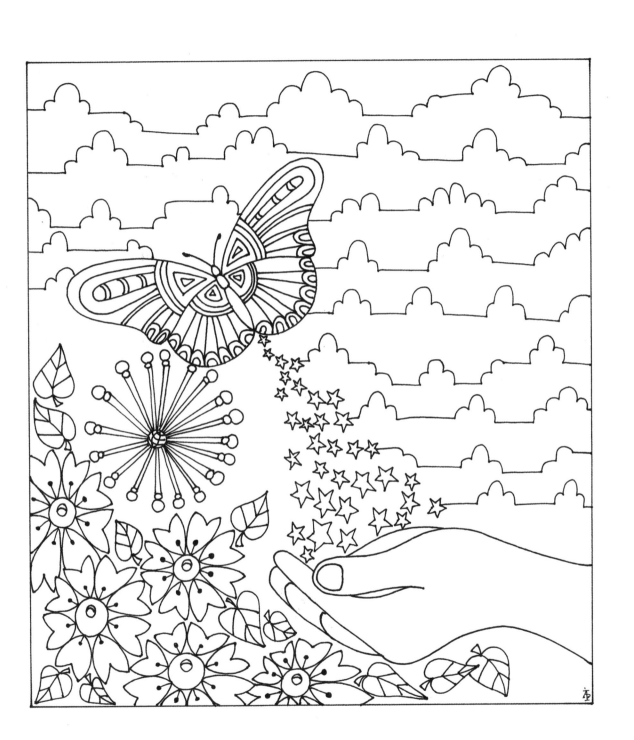

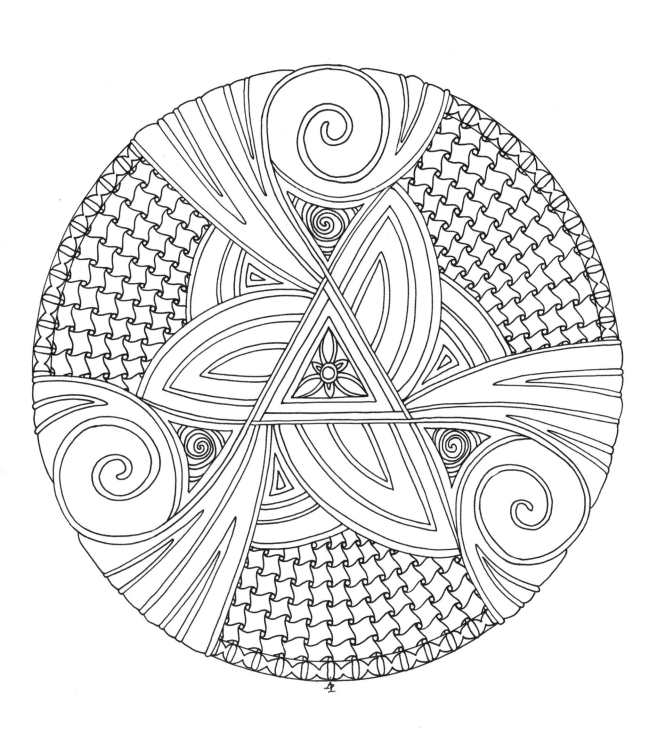